How to Keep a
Sketchbook

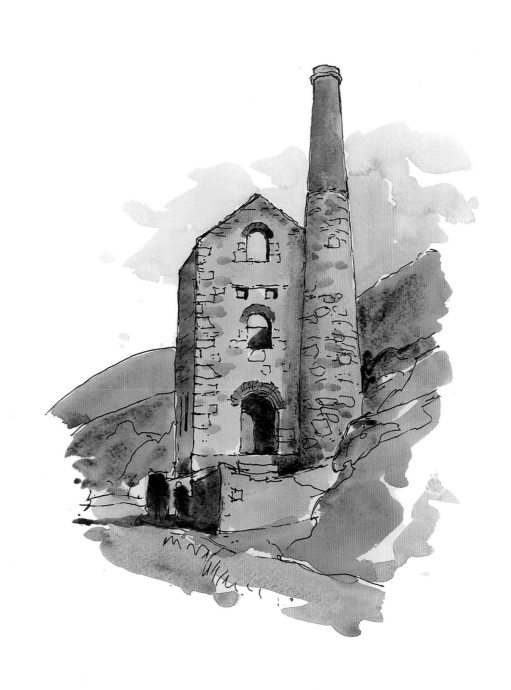

How to Keep a
Sketchbook

Michael Woods

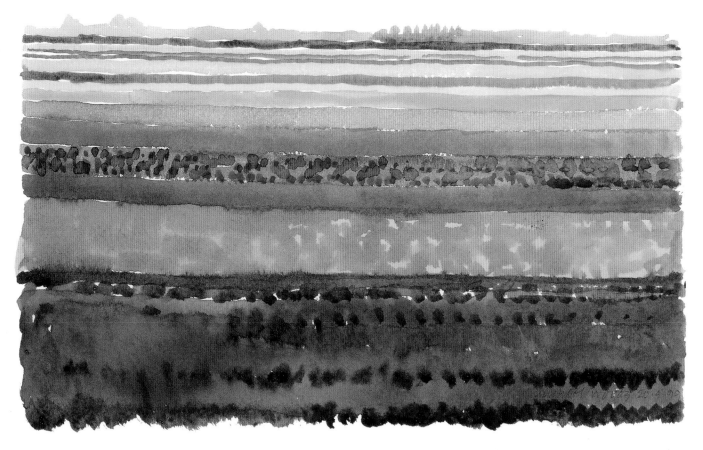

Batsford

Dedication

To Jacqueline, who patiently waited while many of the sketches were made, brought sanity to my manuscript and coaxed the laptop to produce its floppy disk.

Page 3 illustration: Bulb Fields near Amsterdam

First published 2002

© Michael Woods 2002

ISBN 0 7134 8747 X

A CIP catalogue record for this book is available from the British Library.

Printed in Taiwan

Designed by Zeta Jones

for the publishers

B T Batsford
64 Brewery Road
London N7 9NT
England
www.batsford.com

A member of Chrysalis Books plc

Contents

Introduction

A sketchbook often appears to have a life of its own. Looking back through some of mine, it almost seems as if they have visited places and drawn things without any reference to me.

The mixture of subjects seems strange now, and few drawings relate to one another: a rocky seashore, a shop in London, a shelf in a cottage, a Florentine pot, a ship in a dock, a group of men playing bowls. Yet the sketchbook is a very precious thing. My wife teases me about the day I sank into a quicksand and my first reaction was to throw her my sketchbook! Of course it records certain places and particular things: it notes times and thoughts. Some sketches have been developed into much more major works, while others remain untouched. They have been part of the acquisition of information, which in time becomes experience.

Drawing keeps the eye alert and advances the understanding of so much in terms of colour, shape and texture. The sketchbook is available for anyone and, since it makes no rules and can be quite private, it may be used to serve in any way an individual wishes. For some people it might be the illustrated part of a journal, for others the gathering of botanical shapes for a fabric design, or just the gradation of colours in the sky.

For me the sketchbook is an image collecting device: it is not a work book. Nothing is really developed in it though it may record several aspects of something that can come together elsewhere at another time. It is not a scrap book of collected items: it is a book of paper that enables me to work outside, away from my studio, to record and react to things that interest me at that moment.

Sometimes I may not be certain about the merits of a subject and only when I draw do I begin to find out what the potential may be. Yet I never know when I am going to see something that causes me to react. It might be when the light is right, or when someone is in a particular place, or when I turn a corner and what I see surprises me. At that moment, if I had no paper and nothing with which to make a mark – well, what a disaster! Memory might serve, but nature has such an incredible way of making complicated relationships of colours and shapes that some positive record is needed. Even man-made objects have special individual qualities. I remember realizing that I actually had no idea what a London bus really looked like. If I want to draw but am unable to do so I can be a very grumpy man. So virtually all the time I do have materials with me.

Chances to Sketch

However, there are certain types of situation that are worth mentioning, so that one can consider how prepared it is possible to be. First there are times when drawing is most unlikely,

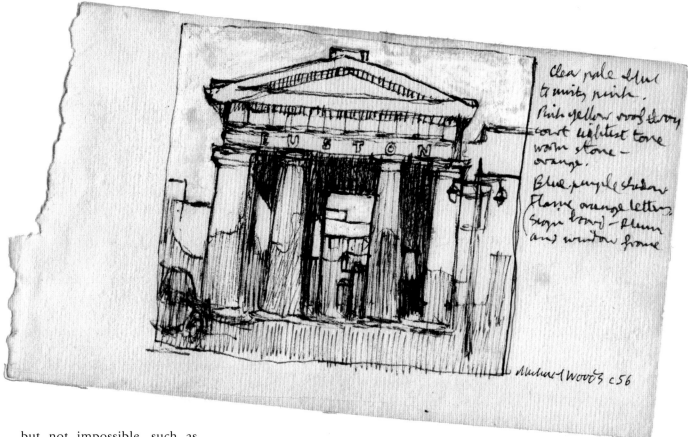

Entrance Screen,
Euston Arch,
London

but not impossible, such as travelling in a car or a plane for instance: shopping or attending a special family occasion are not likely to be productive either. The second is one where drawing could be possible but hazards get in the way, such as time limits or weather conditions. The third is when you know you have a good chance of doing some study, and linked to this is some knowledge of what, in general terms, you might see – a guide book or other photographic images may have been helpful. The fourth is somewhere you already know, and a personal judgement of an ideal place or the particular nature of an individual site may create the desire to sketch if at all possible. Knowing a place can also save time in finding the best drawing spot – which may well mean a longer working time.

Three other factors will also have a strong bearing on how the sketchbook comes about. If materials are limited to what can be contained in, say, a pocket, then the nature of the drawing will be controlled by those facts. If you are out walking for a whole day then what you can carry has to be a factor. If on the other hand you take a good range of materials, then it's quite likely that they may influence everything else.

These seven points sound rather mechanical and quite inhibiting but in actual fact they soon become a natural selection, just like assessing the weather and choosing suitable clothes. However, sometimes when I have been encouraging a person to take up drawing and painting, they having expressed an undeveloped enthusiasm for the subject, I find them rather pessimistic about making time for it. So I suggest an aim, particularly when going on holiday. If one is to be away for seven days,

then at the end of that time at least seven sketches should have been made. Not necessarily made one per day, one morning might be very productive, but the main goal is to have a little bit of a push to get things going.

I've frequently been asked how long a drawing has taken. For those who are interested but do not draw I can understand the fascination of relating the final product to the time taken to achieve it. However, the finished sketch can be quite deceptive – a completed rectangle may look more like a picture than a vignette; a subject made up of clear, crisp structures may look as if it took a long time because it appears accurate, yet it may have been completed in, say, 20 minutes. On the other hand a composition with many gentle forms that bend and weave – a wood for instance – might look unresolved and seemingly briefly executed, yet may have involved 2 hours or more.

Times to Sketch

So the sketchbook can contain many different types of drawings, made for different reasons, with different materials, and absorbing different amounts of time. It reviews life; the landscape constantly changes, many of my subjects have passed and gone, many of the moments are unrepeatable – but they are recorded, and I have selected examples from my sketchbooks that cover not only a broad range of subjects but the differing circumstances in which I made them. In a few cases I have included the work that resulted from the sketch in order that the direction of my thoughts is shown.

There are other times when I go out to paint at a site known to me, on a day when the weather is right and when there are no time limits. I may return to the same place on several days to complete a piece. On those occasions I am not using a sketchbook: I take boards or canvases and an easel, and usually I am alone.

But the sketchbook comes into its own at almost all other times – often when I am with people who are not artists. The opportunity then hangs in the balance and in most cases it is then or never. Generally 'then' wins. But one thing is constant – the thrill of seeing something worth recording and the excitement of getting out the sketchbook and starting to draw.

THE ENTRANCE SCREEN OF EUSTON STATION, LONDON, ENGLAND, C.1956
9 x 13cm/$3^1/_2$ x 5in • PEN AND INK IN AN OLD REPORTER'S NOTEBOOK • 20 MINUTES

The Entrance Screen was built c.1838. I drew it several times as I regularly passed it on my way to the Slade School of Art. Sadly it was destroyed in 1962 for the reconstruction of the station.

Sketchbooks & Papers

The definition of when a set of marks or colours is called a sketch, or when it is a drawing, is not at all clear to me. Probably the most helpful comment that I can make is that a briefly made and possibly incomplete set of marks is more likely described as a sketch. The term 'drawing' might be applied to a work that in itself seems complete. So when it comes to selecting books of clean plain paper, the terms sketchbook or drawing book are not particularly precise. The well-bound small sketchbook can be a charming thing and pleasant to handle in its own right, but to be a working sketchbook it has to facilitate drawing and the individual artist has to make personal choices in selecting it.

The size and proportion, the type of paper and the method of binding have to be decided upon. Thoughts of how and where it is to be carried and with what else quickly follow. The cost may have to be taken into account. For some the answer might be: 'oh, any book will do.' But looking back on my student days I now realize that I did not totally control what I did; the paper I was using had quite an influence, and although a sketch or drawing book was something I used, I had little awareness of the variation in paper qualities. When I was about 13 years old, in the 1940s, my 'art' book was my sketchbook and in many cases older members of the family bought me these as birthday presents. I remember being scared to use one because it had particularly thick paper and I was told not to waste it! Now I appreciate that freedom to use paper is one of the great joys for an artist, and though I certainly do not waste it, I feel it must be freely available – there are enough hazards in the art world without adding lack of the right paper.

Paper Choice

My biggest book is 38 x 50cm/15 x 19^1/$_2$ in, and this is the largest size I can hold while drawing or painting, because I am generally standing up. Size and proportion are quite personal choices. I use a book 25 x 36cm/10 x 14in as my classic size and proportion. Half that size is also very useful – 25 x 18cm/10 x 7in, and 13 x 18cm/5 x 7in fits many pockets or a small bag. 13 x 13cm/5 x 5in is my smallest book and provides paper in restricted circumstances, for example when wearing a dinner jacket.

A bound sketchbook

Above: Ring binding.

back. The effect of this means that the drawing surface is the same size as the book when closed. However it is still an advantage to hold the free edge with either an elastic loop or two metal clips.

Blocks of drawing paper are available where all the edges are lightly fixed with a thin, rubbery plastic. These have an advantage from the wind point of view, but cutting the fixing needs delicate care if the sheet is wet from a watercolour wash. It also has no home while the next sheet is used. Considerable care has to be taken not to scratch the sheets when cutting the edge glue. A flat, very smooth blade is needed, but with no point, and it must be used flat to the sheets. This is not a system that lends itself to fast reactions or to several studies following on from one another quickly.

Most sketchbooks are made using a single paper type. Some, containing coloured paper, may offer a selection of colours in one book, while some manufacturers may offer a single colour such as cream or black.

The relationship between drawing or painting materials and the paper can be crucial. One of the most important factors is the paper's reaction to being wetted. Information must be sought, but even then personal experience as to how much surface distortion can occur is vital if the paper is to work well with this medium. I had one drawing book that was well made – the pleasant matt paper was ideal for drawing, but in the Science Museum in London I used a pen for the first time in the book and found that making several strong dark marks made holes right through the sheet. So it is quite important to get to know different papers. They can be bought by the sheet and the range of types and colours is huge and this presents a new advantage. It is not at all difficult to use a loose-leaf sketchbook. The cover of an old book can be utilized or a home-made cover can be put

I must emphasize that my sketchbooks are used outside all year round: if I use one in a building, then I am a visitor to that place and may find a subject by chance that I want to draw. I do not see the sketchbook as part of the equipment used in the studio – in the gathering sense. A well-bound book has a tendency to be rather full of paper and, when held, the half you are not drawing on has to be kept open. Wind, even the slightest breeze, can quickly flip the sheets, but two elastic tape rings can ease that problem. If the binding is on a book with a broad layout (sometimes called landscape), this unwanted half can be a nuisance; with the vertical layout (sometimes called portrait) it is less so. But standing up, holding a bound sketchbook and a watercolour box in one hand and a brush in the other, is not easy.

The binding that has less charm, but great merit, is the ring or spiral system. There are lots of slight variations, but two or more largish rings pass through holes in each sheet of paper, while the spiral system uses a long spring-like wire or plastic, which passes through holes all along the binding edge of each sheet. This method has the great advantage that the cover and any used sheets can be folded round to the

together with card and tape, or card, fabric and glue. The great advantage is that large sheets of paper can be cut down to convenient smaller sizes and the assortment in the personal sketchbook can include a variety of paper types and colours that can aid the making of sketches enormously. Held by elastic tape, the sheets can be changed very quickly, and at the end of the day the studies can be removed to safe keeping and fresh new sheets added. In this way the drawings and paintings can be kept as clean as possible and the weight of paper carried in any one day can be kept reasonable. Back in the studio the single sheets are simple to work from. Bindings do not have to be cut and several studies that might come to be used together are freely available for comparisons to be made.

So the whole range of sketchbooks and papers now available is most impressive. It really is worth visiting several art shops or art material suppliers and getting to know what is available. Collect catalogues and lists, so that sizes, weights and costs can be compared. I recently needed to make a decision as to which watercolour paper I would use as my main standard paper. I bought individual sheets and over a period of about two years tried them out on real subjects because I've always found that doing little tests alone did not always reveal the subtle qualities that some papers have. In all I tried 35 types and variations.

Paper Weight

Handle sketchbooks. Judge how heavy they feel. Look at how they are bound and how they

Left: Different paper samples.

open. Within one maker's range make a note of all the sizes, and which way round they are bound. Paper weight is important. The traditional system, which is still in use, gives the pounds weight per ream. A ream is 480 sheets, now likely to be 500 sheets taking into account metrification of the specified size. The metric form uses the weight of grams per square metre. This does not depend on the size of the manufactured sheet. So a fairly thin drawing paper might have a weight described as $96g/m^2$ or 45lb; a cartridge paper might be $150g/m^2$ or 70lb; a good watercolour paper might be $300g/m^2$ or 140lb; and a thick watercolour paper might be $425g/m^2$ or 200lb.

In less expensive books cartridge paper may be used. This is excellent for drawing and the paper may range between $96g/m^2$/45lb and $220g/m^2$/100lb. Thinner paper will be cheaper and lighter but less robust, while thicker paper will be heavier and more expensive but more durable in working conditions outside. But cartridge paper, particularly thin cartridge, is not happy being wetted. Since sketchbook work tends to be quite varied (well mine is anyway), washes of watercolour will be used on some occasions and, of course, the pages in the sketchbook are used just as they are bound: stretching watercolour paper on a board is obviously not possible for sketchbook work. When even lightly wetted, thin paper will wrinkle; the heavier, thicker paper will be more tolerant. I would suggest that $150g/m^2$/70lb is the starting point for wetting and it should be described by the manufacturer as suitable for watercolour.

The surface of paper has a great influence on the drawing instruments. Cartridge tends to be matt and smooth. Mould-made papers are usually available in three surfaces. 'Rough' is just that, taking on the texture from the making process; 'Hot Pressed', known as HP, is the smoothest surface achieved by heat and pressure. 'Not' surface – 'Not' referring to Not Hot Pressed – is between the two. It is also known as 'Cold Pressed', CP. Some papers may be too smooth for some techniques, while others too rough. Some surfaces can look very mechanical. Pens can catch on the slightest texture. Some papers may be quite soft and absorbent but sharp pencils can dent the surface.

So, if new materials are being tried, select a sketchbook about 18 x 25cm/7 x 10in with a ring binding system that permits a complete folding back of cover and pages. Select two or three sheets of other types of paper, making a note of their name and weight, and when possible transport them in a portfolio. (Rolled paper never wants to unroll!) Then subdivide the sheets into, say, 25 x 36cm/10 x 14in, mark each with a little identifying code and cut two stiff card covers just slightly larger – 26 x 37cm $10^1/_4$ x $14^1/_4$ in – and, with two bands of elastic flat tape, hold the little pile together. Keeping a record of which paper is which, is very important. Even if a hand-made paper has a watermark it will only appear once. Identification of papers can be facilitated by holding the sample in front of a bright spotlight; the watermark (if there), the paper's texture and its colour will all become surprisingly clear. Two papers that look similar on their surface will reveal variations when examined in this way. Keep together any off-cuts with their name, surface, weight and colour stated – they can then be quickly compared.

Drawing Materials

Any materials you choose to use must work well. A pencil with a broken tip or a fountain pen that has dried up are useless. So it is worth giving time to the selection of these materials.

The great classic is the pencil. Select a good make that you can keep to so that all the hard and soft grades will relate accurately to one another. An HB is good for fine pale marks; a 2B is a good general grade – it will not dent a soft paper if handled gently, but it will deliver a rich dark line without losing its tip too quickly; a 4B is probably soft enough for vigorous, quick drawings. Remember that all the marks can smudge so they need protection as soon as possible. Even in a well-bound book the pages will slightly agitate and fuzz originally crisp lines.

It is important to have a good quality eraser. Synthetic ones made by a good art supply company can be excellent, and cut in half or quarters, or even sharpened, they can be used more delicately for cleaning up odd accidents or dirty finger marks. Do test erasers on all your papers to see what results you get.

A black and a white pencil are enormously useful. Karismacolor make a fine, rather waxy range. They work well on mid-tone paper and there is little problem with smudging. Recently I was drawing a rough sea with them on 300g/m^2/140lb card when my drawing was blown into the water. Although it was in salt water for 10 minutes or so, the Karismacolor was unmarked and the card had dried totally flat by the next day. Pentel make a good, white roller pen called Hybrid. It is remarkably opaque and delivers the line well. But manufacturers change their ranges and names quite frequently, so always be prepared to experiment with something new. As well as black and white, most manufacturers make extensive ranges of coloured pencils. Three or four carefully selected for a predicted specific use can be excellent but sets or groups of 10 or 15 pencils can be very ungainly. It is difficult to hold them all while also holding a sketchbook, and sharpening them poses quite a problem because everything else then has to be put down.

Most individual colours will not be the ones wanted, and mixing is not always very effective. It is also a slow procedure because the building up of colour has to be gentle, as strong early marks cannot be lost by overworking.

Chalks and pastels are slightly better as they do mix more readily, but they require more working time than sketching usually provides. Oil pastels are strong in colour but subtle mixes are not easily achieved. Brand new boxes are fine for a short time, but personally, I have never been that enamoured with a box of bits of any type of chalk because the colours soon become difficult to identify, particularly when working quickly. But it will be the type of subject and the individual's preferences that

*Cut-down
paintbrushes in
a small case,
and field brush*

will decide the final choice.

I like pen and ink; I've always liked the positive statement that it makes. A bottle of black ink and a metal tipped dip pen (medium tip is probably most useful) make a wonderful drawing combination, but only in ideal conditions are they without enormous hazards. Bottles of ink can spill! The Rotring Art Pen is the best fountain pen I've tried that flows well with drawing inks such as Royal Talens Ecoline, which is water-soluble, and also works well with acrylic inks, which are water-resistant. Higgins Black is an excellent permanent black ink. But like all fine tools the Rotring Art Pen needs regularly washing out, cleaning and refilling. When cared for it will

carry on flowing as fast as you can draw. For sketchbook use it is ideal with a choice of nib sizes. I find it an advantage to keep two pens loaded with the same ink as this provides many hours of drawing time. Proprietary brands of unrefillable pen, after a year or so, may need testing for a smooth ink flow. If in doubt, it's probably best to buy fresh ones.

Another important material is a watercolour box. Mine is made of brass and holds fifteen colours in half pans, three mixing areas and a small supply of water. When closed the water holder fits over one end, holding the whole unit together. Although the box is quite heavy, it is small and can be held easily. From time to time I change

some colours: the time of year or some particular subject might be the cause, but the range shown is a basic guide.

In addition I hold Sepia, Ivory Black and Titanium White in a separate box – as just occasionally they are useful.

There are a few other items that I find helpful: sheets of kitchen roll, folded in quarters; a small craft knife with break-off segments; a small bag for rubbish and a large plastic bag to put things on or sit on if the ground is damp; and a hat of some sort – you can be quite vulnerable to the sun when standing still for half an hour!

Brushes with a wooden handle are simple to cut down in length. The cut should be smoothed with sandpaper. They are excellent to use when sketching and will pack into a very small case, 11cm/4^1/$_2$ in square, which can be made from fabric or leather. A piece of stiff plastic sheet makes a firm back to protect the hairs and Velcro tape keeps the closed case secure.

A field brush is a really useful little brush. The handle is hollow and when in use measures 10cm/4in long. When not in use, the handle unplugs and acts as a cap to protect the hairs and is then only 7cm/2^3/$_4$ in long. I keep one in my pocket at all times.

It is perhaps worth mentioning here that when sketching in exhibitions or museums, or any historical building open to the public, it is unlikely that wet materials will be permitted. By that I mean no use of water. Pens containing their own ink are fine, and spit will provide the medium to make a gentle tonal wash. I always ask for permission to draw and, when granted, I try to keep well out of the way of other visitors, partly to avoid being a nuisance to them, and partly so as not to get jostled.

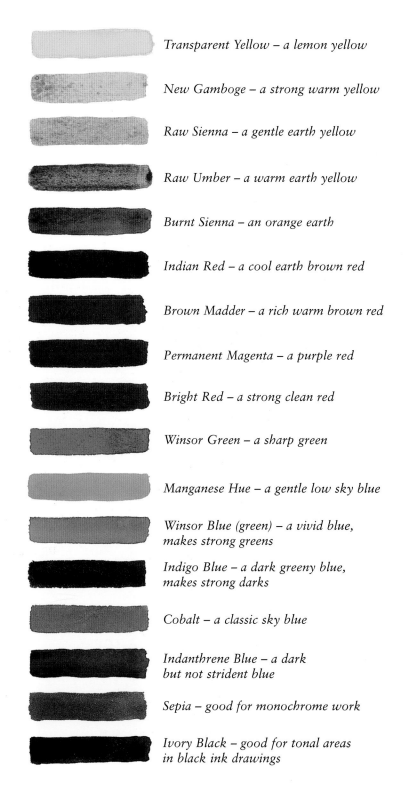

Transparent Yellow – a lemon yellow

New Gamboge – a strong warm yellow

Raw Sienna – a gentle earth yellow

Raw Umber – a warm earth yellow

Burnt Sienna – an orange earth

Indian Red – a cool earth brown red

Brown Madder – a rich warm brown red

Permanent Magenta – a purple red

Bright Red – a strong clean red

Winsor Green – a sharp green

Manganese Hue – a gentle low sky blue

Winsor Blue (green) – a vivid blue, makes strong greens

Indigo Blue – a dark greeny blue, makes strong darks

Cobalt – a classic sky blue

Indanthrene Blue – a dark but not strident blue

Sepia – good for monochrome work

Ivory Black – good for tonal areas in black ink drawings

Chapter 3

Examples

Unexpected chances

Vaporetto Quay **VAPORETTO QUAY, VENICE, ITALY, 1997**
• 20 x 28cm/8 x 11in • BURNT UMBER
WATER-RESISTANT INK, BLACK WATER-SOLUBLE
INK, WATERCOLOUR ON FABRIANO MURILLO
260g/m²/120lb PAPER • 15 MINUTES

I had not arrived at Venice's Marco Polo airport before and I was surprised to see how close the water was as I left the building. Immediately, the milky green water and tall wooden posts exerted their visual charm. Luckily I was able to leave the luggage to the care of my wife and sister-in-law so that I could draw the rather odd mixture of jetty and

Ferry boat

posts. The quay is a mooring for quite a number of boats, so some left and others arrived while I was sketching. Warm brown acrylic ink is quite good for laying out shapes because its tonal value is about half that of black. I mixed a few washes to start the colours but it all looked a bit pale and soft when, in fact, the structures and the movement of the water were really rather strong. To deal with this I started drawing with a pen with water-soluble black ink, strengthening the handrail and the concrete under-structure, just as the water-bus arrived. Managing to keep the wet paper from being touched, we boarded, and I made a few last swipes with a wet brush moving some of the black ink to make bigger areas of tone. Once I had gathered my things together I then enjoyed the fabulous journey by water to St Mark's Square.

FERRY BOAT, PORTSMOUTH, ENGLAND, 1991

- 18 x 23cm/7 x 9in • BLACK WATER-SOLUBLE INK, WHITE PENCIL ON DARK GREY PAPER 150g/m²/70lb
- 30 MINUTES

Travelling to France with family, we had arrived at the port at night. Cars waited stationary in queues and as I was not driving I decided to make a drawing of the features of our ferry that I could see through the car window. There were many floodlights, and the white painted parts of the superstructure showed up rather well, although revealing no great maritime beauty. This sort of drawing can sometimes be useful in aiding a background or distant element in another composition. I continued until our line of cars started to move. Grey paper, with black and white drawing instruments, makes good tonal studies.

DIDCOT STATION, ENGLAND, 1953
- 10 X 15CM/4 X 6IN • BLACK WATER-SOLUBLE INK ON VERY THIN PAPER • 10 MINUTES

This little drawing must have been made during my National Service days. Trains seemed to stop for quiet, still periods when for a short time nothing happened. In this sketch the clutter of signals and telephone lines now, strangely, sum up the 1950s for me.

CARLISLE STATION, ENGLAND, 1993
- 20 x 28cm/8 x 11in • BURNT UMBER, WATER-RESISTANT INK, WATERCOLOUR ON WHATMAN 300g/m²/140lb NOT PAPER • 30 MINUTES

A railway station is one of those classic places where we wait. We become ornaments placed on a platform, and we wait for someone to arrive or to be taken to another destination. I was with a school group and we, schoolmasters and pupils, had left our beds halfway through the night in order to reach Hadrian's Wall and travel across England during the day, studying the Roman architecture.

Our return journey was from Carlisle on the west coast, but the train was delayed. Several of us had been drawing during the day but now most of the group were tired and the delay didn't help. As the evening light began to fade, the sweep of the station was theatrically dramatized by the glowing blue sky. Since the train was still half an hour away I had time to react. My ink pen was filled with a warm brown

Didcot Station, England

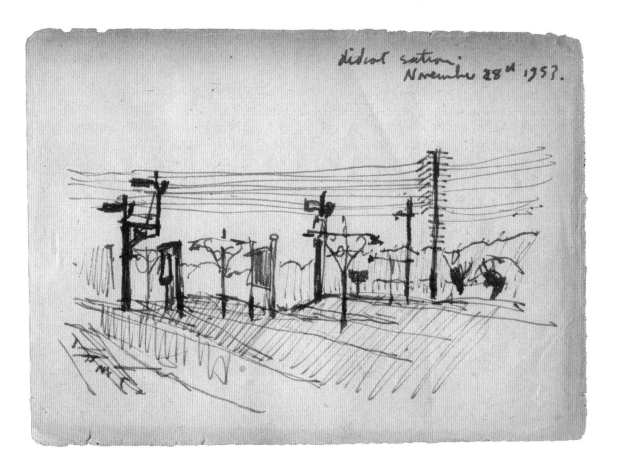

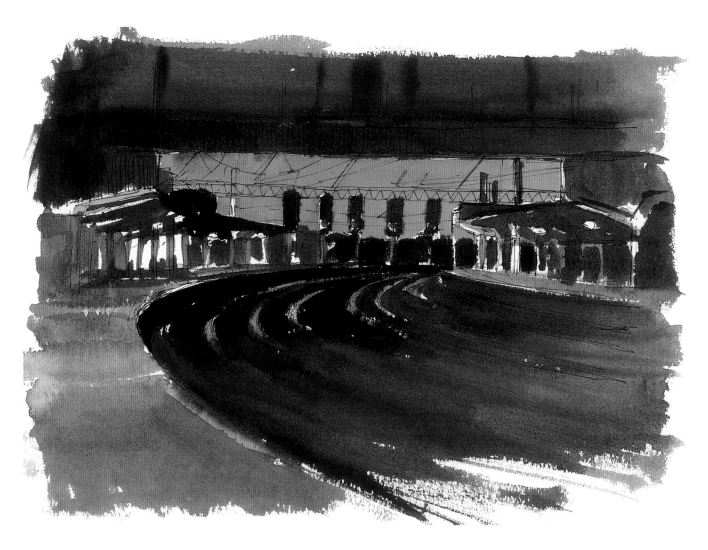

Carlisle Station, England

ink chosen for its sympathy to Hadrian's wall, but it served well to lay out the main curve of the lines against the two platform edges. The rail tracks themselves were almost invisible except for the top edges where the sky reflected off them. Lights began to flick on along the platforms, though these platforms were virtually empty of people in my view ahead. I allowed the illuminated areas to remain white paper, for all my washes were still wet and flooding would have occurred immediately. I can still count four red lights on the signal panels but they became sullied with the dark wet pigment around them. Dark colours in this sort of subject can be a problem – particularly as daylight fades. Black rarely works, and anyway I don't have it in my main watercolour box. Here the darks were made up of Indian Red, Indigo Blue and Raw Umber, but it was hard in the gloom to truly identify the colours I was mixing. For this reason it is really helpful to know the layout of the pigments in your box and understand how they will react with one another.

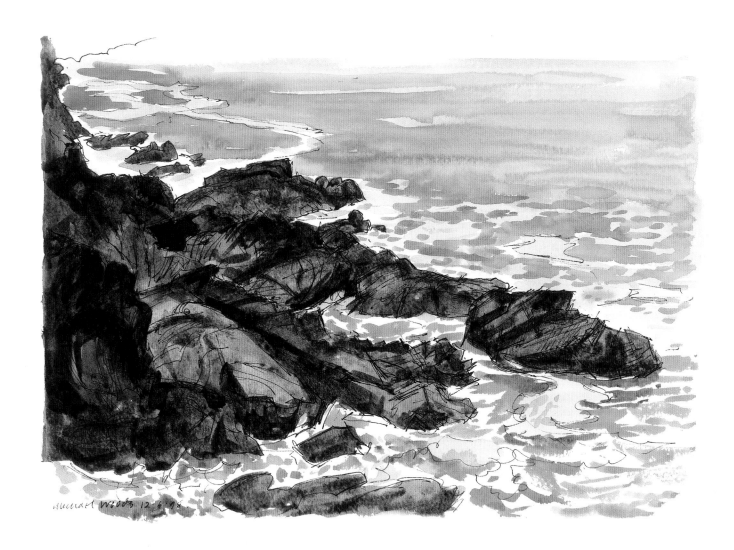

Water's Edge

The Lizard, on the Cornwall coast

I've always loved water. I grew up only 20 miles from the North Sea, and the coastline that is so much a part of my Norfolk landscape has always been close. So it's not surprising that now I always take every opportunity to draw it. Yet I can remember when I was frightened to try. People in art schools don't tell you much about the sea, but looking at paintings and trying to deal with what's happening on an actual coast gradually opens up a subject of enormous potential.

THE LIZARD, CORNWALL, ENGLAND, 1998

• 25 x 33cm/10 x 13in • BLACK WATER-RESISTANT INK, WATERCOLOUR ON BOCKINGFORD 425g/m²/ 200lb PAPER • 40 MINUTES

Many things that are visually exciting may not be seen until the last moment. It is the surprise of turning a corner and finding something that arrests the attention. The coast line round the Lizard is just like that. The relatively flat land suddenly stops where the sea's pounding has broken it down into dramatic rocks. The rich colours and the sea, alive with spray and foam, were thrilling. I immediately made a rough framework of structure with black water-resistant ink. I generally find that to sort out the placing of parts aids my judgement of the colour that follows. It also means that at both stages I can work very fast, which has the advantage that the structure keeps the vitality of the whole, while the colour washes can be fresh and quickly applied. The foam and froth were so bright that in many cases I left the paper untouched.

The White Cliffs of Dover, England, c.1990
- 15 x 48cm/6 x 19in • Water-soluble pencil, medium cartridge paper in bound sketchbook
- 10 minutes

It was a beautiful bright day leaving Dover Harbour and heading out across the English Channel towards France on the ferry. I had extracted a broad sketchbook for I anticipated that the white chalk cliffs would be worth drawing. I selected a page where the two sides were actually one continuous sheet with only stitching in the fold. I suddenly realized that the ferry was travelling quite fast and the cliffs were receding quickly. They would really only remain at a good size for a few minutes, so I drew quickly and vigorously with a pencil that was water-soluble. I then used a field brush with spit to make a tone for the grass on top of the cliffs and again on the sea. This to some extent made the white cliffs look pale by contrast.

Hastings Beach, England, 2000
- 23 x 33cm/9 x 13in • HB pencil, wax stick, watercolour on Bockingford 425g/m²/200lb paper • 30 minutes

Another version of the breaking edge of waves was made at Hastings. The viewpoint of being at sea looking back at the beach can be obtained from groynes, harbour walls and piers. What attracted me here was the quality of the breaking foam just before each wave ran up the beach in its thin wet film and then dropped back under the next wave.

I found the best viewing place and watched the waves for 5 minutes or so. The shapes of movement will repeat themselves, so once I had observed and understood the most characteristic wave movement, I drew the main shapes with an HB pencil. Then, in order to protect the paper's surface where the strongest foam was, I shaded with a little wax stick (see Technical Notes). Because the paper has a mildly rough surface the wax did not cover evenly nor did it have a harsh

The White Cliffs of Dover

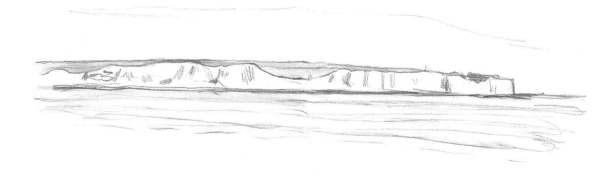

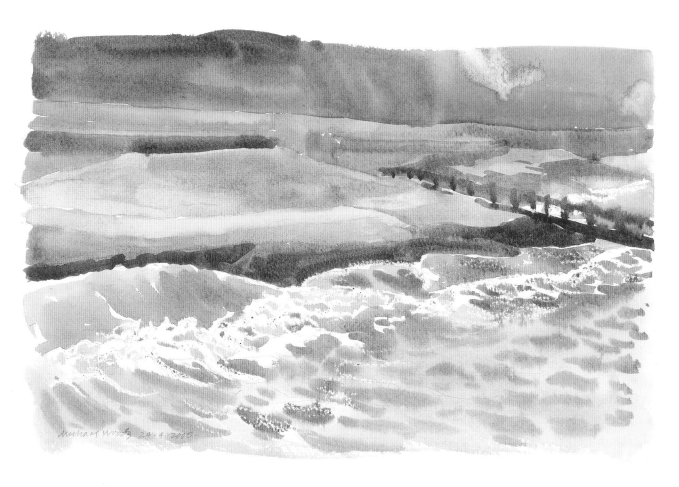

Hastings Beach

straight edge. I then painted the watercolour washes freely knowing that I wouldn't have to tickle round the white foam and froth. The most difficult part was the run of the water up the stones of the beach, for it only lasted a few seconds each time, and I knew that I only had one chance to get the right colour and tone.

HASTINGS TOWARDS BEACHY HEAD, ENGLAND, 2000

• 18 x 23cm/7 x 9in • BLACK WATER-RESISTANT INK WHITE ROLLER TIP PEN ON GREY 150g/m²/70lb PAPER • 20 MINUTES

I saw this view towards Beachy Head and decided that the almost calm sea and wet sand reflecting a lovely cluster of clouds was worth recording. I selected my 18 x 23cm / 7 x 9in) sketchbook because the view was just about my sight size on that paper.

I started drawing in black ink and, when that was complete, continued with a white ball pen. One of the problems of a sketch like this is that it may not always deliver as much information as might be assumed at first glance. The subject may be charming, and the sketch can evoke something of the atmosphere, but if it is to be called on to act as an advisor to a more major painting or print, it may not be as helpful as might be hoped. In this particular case there is no suggestion of any change in the tone of the sky from above the clouds to the horizon and quite a large area of the

sea is untouched paper. In other cases the sketch may not have been made in a crisp rectangle. When selecting the compositional rectangle suitable for a canvas one or more corners of the sketch may be totally blank. Sometimes this can matter quite a lot. So, one of the benefits of developing a sketch into another medium, like a print, is that it reveals how much information the original sketch contains and this assessment can benefit future drawing.

NORTH COAST OF CORFU, GREECE, 1995
• 36 x 25cm/14 x 10in • BURNT UMBER WATER-RESISTANT INK, WATERCOLOUR ON HAND-MADE INDIAN PAPER • 1 HOUR

My wife and I walked quite a long way on a holiday in Corfu. In several places the coast was reached by dropping down little valleys to dramatic cliffs climbing out of the vivid water. Here the layers of strata were quite remarkable, but the blue and green of the water was so powerful I found some of the colour difficult to achieve. Back in England, and looking again at some of the studies, the blues and greens look too intense. This may be because my original mixing of the colours was not quite right, or it may be that they just look too bright compared with the grey seas of my native Norfolk coast. This sort of jolting record from a sketchbook is in many ways what it is all about, and sometimes I think it is important to have to struggle in a

Hastings towards Beachy Head

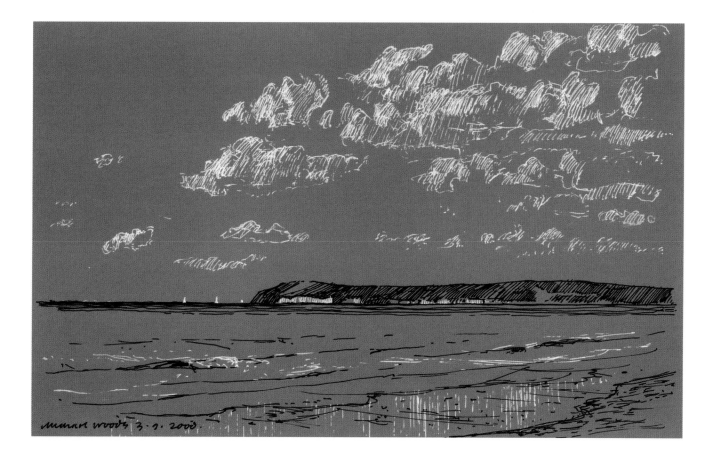

Minard woods 3.7.2000.

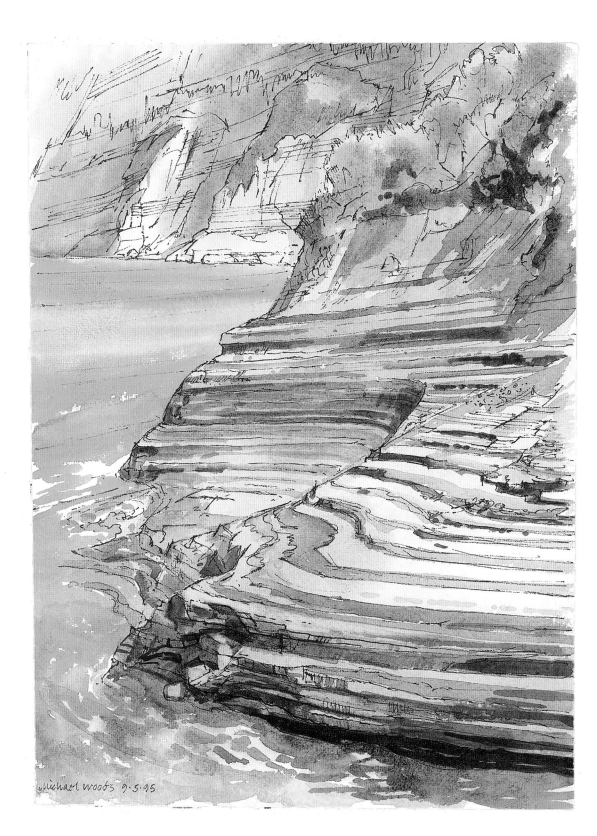

Coast of Corfu

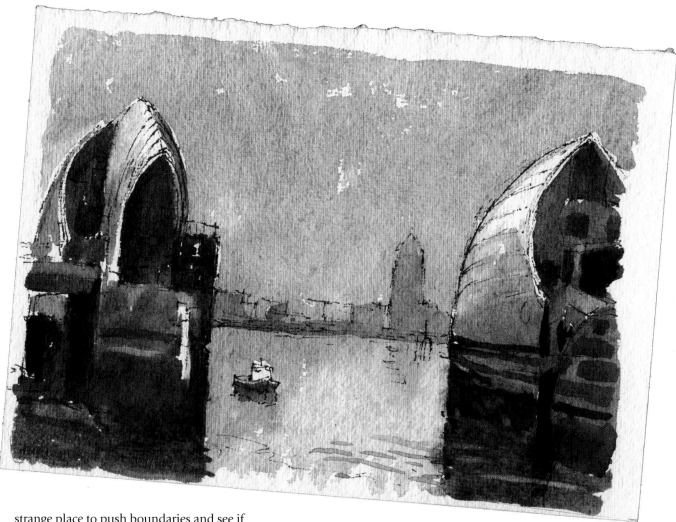

strange place to push boundaries and see if
your judgement can cope with a new experience.

THE THAMES BARRIER, LONDON, ENGLAND, 1994

• 13 x 16cm/5 x 6¹/₂in • BURNT UMBER WATER-
RESISTANT INK ON HAND-MADE INDIAN PAPER IN
BOUND SKETCHBOOK • 30 MINUTES

We were passing through the south of London
and decided to detour in order to look at the
Thames Barrier. It was an overcast and rather
heavy day but the structures still looked
massive. I found a view of the Canary Wharf
Tower between two of the helmet-like gothic
cowls. When dealing with architectural

subjects, or where there
is a strong structure that seems important to
the integrity of the statement, I frequently use
pen and ink. It does mean that I cannot alter
or remove the marks at all easily and I like
this decisive obligation to get my judgements
right first time. The shorter my working time
the more my decision making is on high alert.
I had just finished the layout when a launch –
police or harbour master – came into view
and stopped. I was delighted because it
immediately gave a sense of scale to the
buildings, which up to that time had no
commonly recognizable forms. I then used
watercolour to give bulk to the masses.

*Thames Barrier,
London*

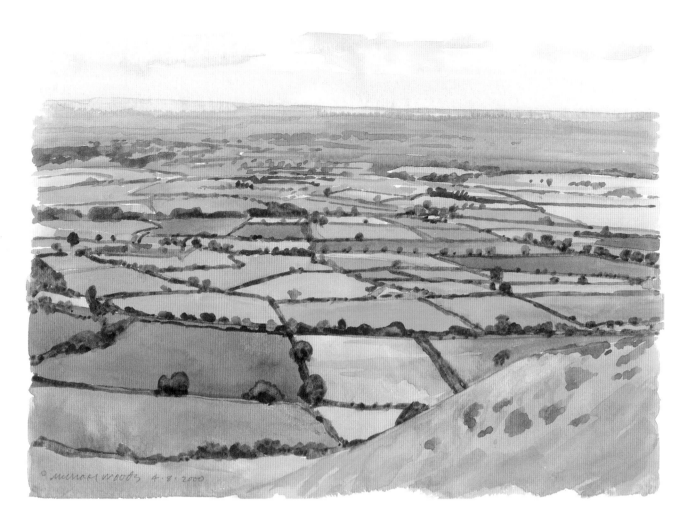

Landscapes

WILTSHIRE FROM WESTBURY WHITE HORSE, ENGLAND, 2000

• 25 x 33cm/10 x 13in • WATERCOLOUR ON BOCKINGFORD 425g/m²/200lb PAPER • 1 HOUR

This was a day out with two of my grandchildren. We decided to take a picnic to watch model gliders and hang-gliders being flown. The view of the fields below us was most impressive, with some fields being purple brown, others orange fawn and the rest various greens. I felt that, although I

would have to be brief, I simply had to take this opportunity, so Grandad was painting…again!

The main decision I had to make concerned the best sequence: to paint the boundaries and then apply the field colours, or to place the field colours – butting them close – and then apply the hedges and trees. I decided on the second option, because the wetting of the fields would have re-wetted the hedges and trees and the colours would have intermingled uncomfortably.

FROM CLEY HILL, FROME, SOMERSET, ENGLAND, 2000

- 18 x 23cm/7 x 9in • BLACK INK IN BRUSH PEN, WHITE PENCIL ON GREY 150g/m²/70lb PAPER
- 20 MINUTES

The weather was very variable – overall rather grey and dark, though now and then a splash of sunlight raced across the fields in the shallow valley. I decided to use a Pentel brush pen for the trees and hedges because it delivers large areas of black ink quickly, then, with white pencil, added patches of strong light to bring some life to the middle distance.

FROM GLASTONBURY TOR, SOMERSET, ENGLAND, 2000

- 18 x 25cm/7 x 10in • BLACK WATER-SOLUBLE INK, B PENCIL ON BOCKINGFORD 425g/m²/200lb PAPER
- 15 MINUTES

Climbing Glastonbury Tor in February was rather good because the air was clean and crisp, and, standing in the lee of the Church tower that remains on top, I made a pen drawing of the field pattern that lay some 150m/500ft below. I added pencil to place trees and to block in bigger areas of wood.

Later I decided to make this drawing into a print. One of the advantages of working from sketchbook images is that they are frequently quite small so they can be used at the same size. The resulting linocut was printed using a blue–grey ink, which gave a stronger winter quality than the drawing.

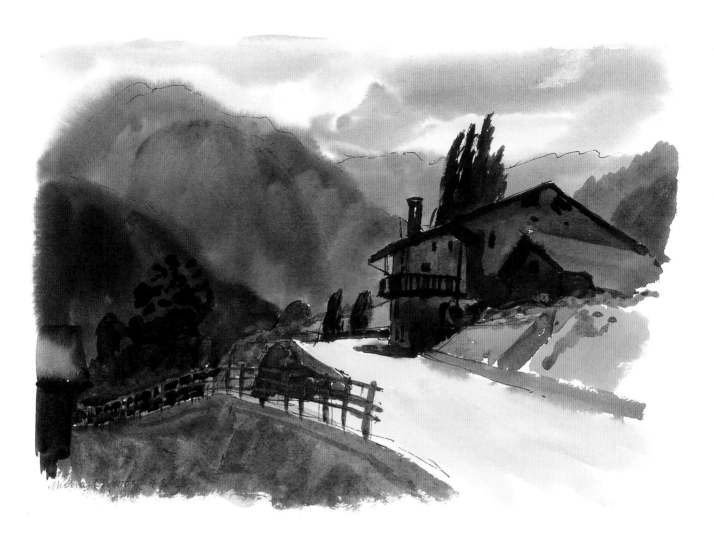

ROAD THROUGH THE ALPS, ITALY, 1990
• 23 x 33cm/9 x 13in • BURNT UMBER WATER-RESISTANT INK ON WHATMAN 300g/m²/140lb NOT PAPER • 30 MINUTES

Road through the Alps

Landscape tends to be big, so to attempt to describe mountains and valleys on a small piece of paper can seem foolish. But if you are presented with a good set of relationships, as in this case the house related to the mountain, some of the problems of describing size and distance will be more effectively solved.

We had just driven over the Alps and, having found a camp site and pitched our tent, we went for a walk at about 4 o'clock. I thought this view back up into the mountains was stunning; the house and the light on the road gave scale and distance to the bulk and mass of the mountains and this in turn seemed to sum up the curious quiet that lay in the valley.

PORTH YR OGOF, WALES, 1997
• 25 x 33cm/10 x 13in • BLACK WATER-RESISTANT INK, WATERCOLOUR ON INDIAN HAND-MADE PAPER • 40 MINUTES

The river has cut itself into the rock and disappears into a broad low cave, continuing through various tunnels until further down it rises to the surface again.

The extreme range from strong sunlight to the velvet darkness of the cave made me feel that I should try to keep as much paper white as possible. So if you expect that a sketchbook study tells the truth, then no. This one certainly does not, yet of course in its descriptive attempt it tries to do so. As any painting can only range from white paper to dark blue or black paint, priorities have to be weighed up. The dark shape of the mouth of the cave seemed to demand the main focus. The rock surfaces could then pull away. Notice that where some of the black pen lines have been covered with a wash of colour, the ink has slightly flooded. This happens with some waterproof ink before it has thoroughly dried. The advantage is that one gets a muting of some colours and a softening of lines and edges, in this case the rock formation.

Porth Yr Ogof, Wales

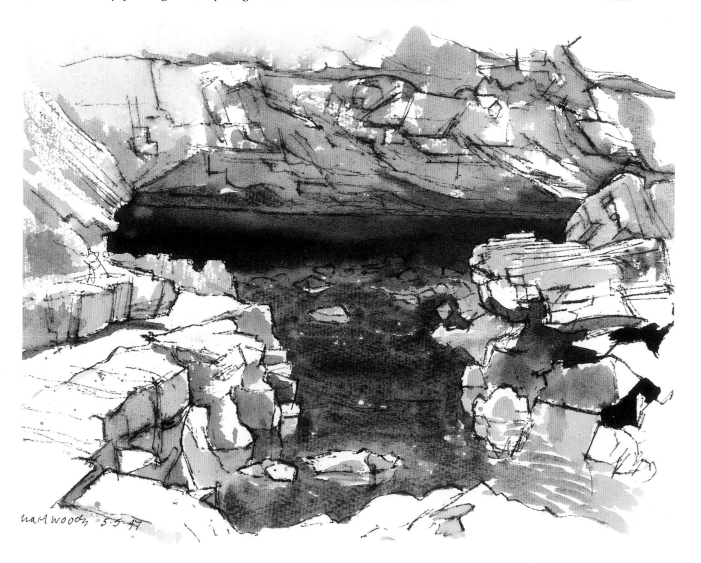

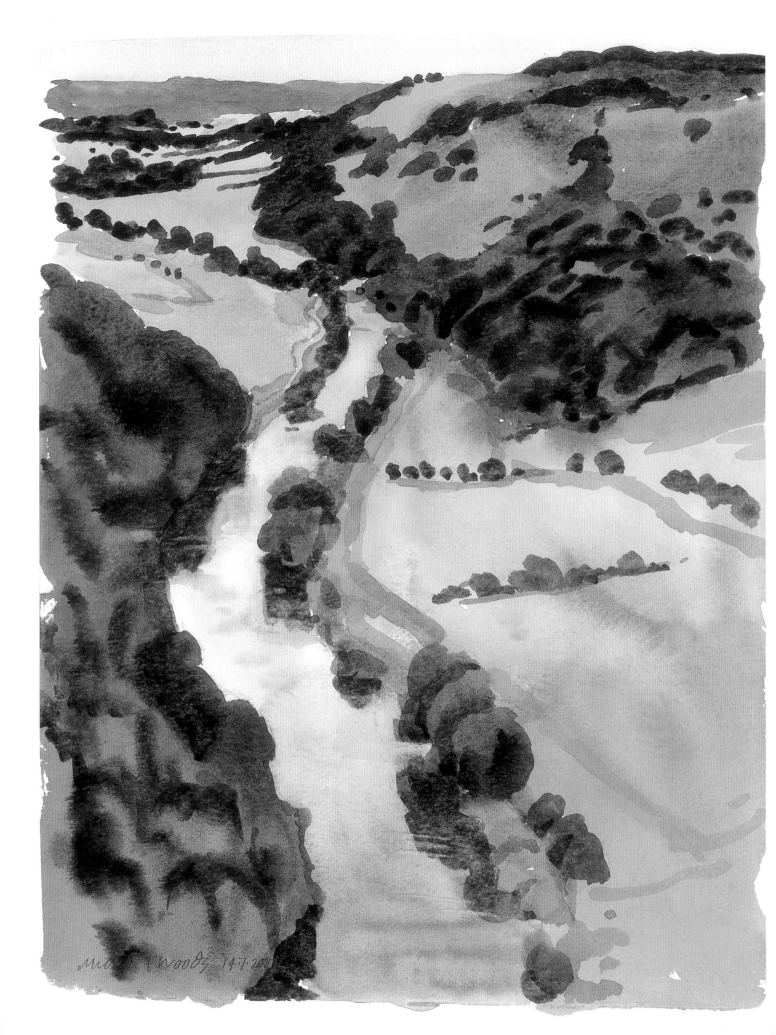

Marston Woods 14-7-2000

SYMONDS YAT, WYE VALLEY, ENGLAND, 2000

- 33 x 25cm/13 x 10in
- HB PENCIL, WATERCOLOUR ON BOCKINGFORD 425g/m²/200lb PAPER
- 40 MINUTES

Once again it was suggested I had a look at this spot. I am constantly grateful for such recommendations and this part of the Wye Valley is stunning. The range needed for the eye in this view is just about the limit. If you look at the bottom of the composition you cannot see the skyline and the reverse is true as well. Yet I wanted to get in the valley ahead, with just a little bit of sky, although at the bottom of the composition I am looking at the water at something like 45 degrees. I used an HB pencil to lay out the shapes. In order to reach this spot I had been walking and climbing steep hills for 1¹/₂ hours, which limited my range of materials. Had I taken my largest book with me I would have felt freer to get the whole area in. This is a good example of how the situation controls reactions. It was a bright but grey day and I had to be careful to keep the tones of the water and fields accurately related.

To develop a sketch into a major painting may depend on whether there is something more that wants to be shown. Sometimes there clearly is, but just one study may not have collected sufficient information or feeling. Many subjects can require a lot of supplementary facts – shapes can be critical; a sketch can get an effect, but the quality of some forms may have escaped attention.

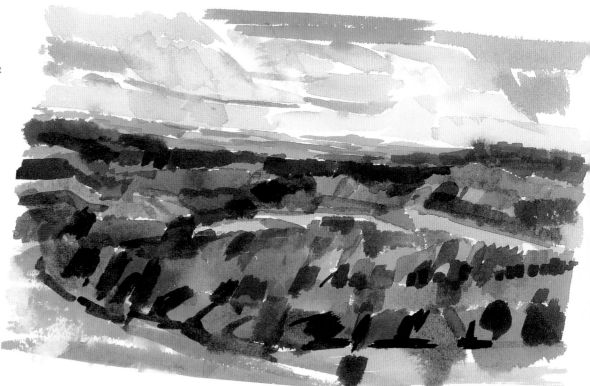

NEWLANDS CORNER, SURREY, ENGLAND, 1993

- 18 x 27cm/7 x 10¹/₂ in • WATERCOLOUR ON HAND-MADE INDIAN PAPER • 30 MINUTES

This landscape is really just a study in colour. Tight information about the nature of the clouds, the form of the woods or the shape of the trees, does not exist; but definite statements about all the colours and the relationship between these colours, does. This sort of study could contribute much to the whole understanding of a particular landscape.

Opposite:
Symonds Yat,
Wye Valley,
England
Above:
Newlands
Corner, Surrey,
England

LAVA FIELD, LANZAROTE, 2001
• 13 x 33cm/5 x 13in • BLACK WAX PENCIL ON 150g/m²/70lb CARTRIDGE PAPER • 10 MINUTES

In selecting one of the Canary Islands to visit for a holiday, my wife and I scanned guidebooks and various articles before deciding on Lanzarote. We were not seeking a beach holiday but the volcanic nature of the whole island sounded interesting. However, none of the descriptions we had read came anywhere near to the experience of being in volcanic craters. The island is quite remarkable and the National Park particularly so. The extraordinary texture, on a huge scale, of the lava fields, the sombre colours of dull blue, red, grey and green at the points of eruption, and the fact that much of the erupted material had not broken down meant that I was presented with a totally new landscape to anything I had seen before.

It was quite difficult to find a spot to make a brief stop to draw, but a track turning off the main road provided one. The lava lumps were huge and the crevices between them quite lethal, yet there was a texture and a sort of logic that I tried to unravel by trusting that my judgement of drawing would carry me through with some degree of honesty. The nearest comparison I could make was the sort of texture one might find on a much enlarged photograph of dust.

VOLCANOES IN TIMANFAYA NATIONAL PARK, LANZAROTE, 2001
• 25 x 33cm/10 x 13in • WATERCOLOUR ON BOCKINGFORD 425g/m²/200lb PAPER
• 40 MINUTES

Later at the visitors' car park in the centre of the National Park I painted two views. This one has three volcanoes in sight and the purple greys and Indian reds were most beautiful in a sinister way. On the first sketch I had to start a second time. I had seated myself out of the very strong wind close to a small wall and was aware of the demonstrations going on not far away where visitors were

Lava field on Lanzarote

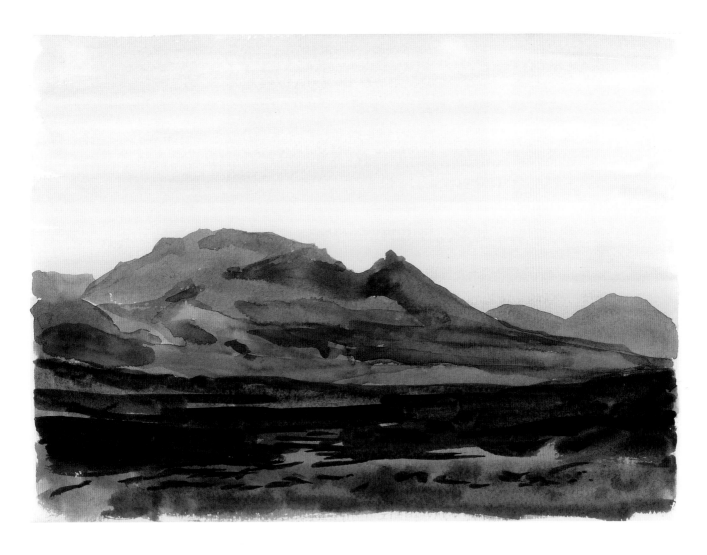

shown the heat of the ground by a bucket of water being poured down a hole to eject a few seconds later as a blast of watery steam. However, I had not realized that, although I was well away from this mini eruption, I was still down wind of it and on the next demonstration both I and my paper were covered in dirty water spots. I moved!

Some weeks later I worked on several paintings and prints derived from the sketches I had made. I really enjoyed working from the volcanoes on site, but at times the wind was very strong and not easy to cope with. Working in my studio provided much calmer conditions where I could concentrate on the compositions and the painting and printing processes. However, I've always found it worthwhile to tackle any development paintings as soon as possible, because my memory of the atmosphere, colours and textures is best when fresh. I have also found that as the seasons change, so do my reactions to colour and light.

Volcanoes in Timanfaya National Park, Lanzarote

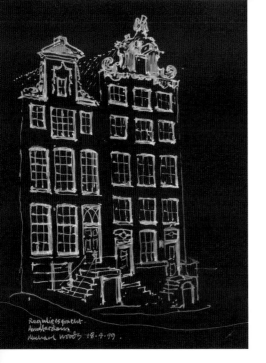
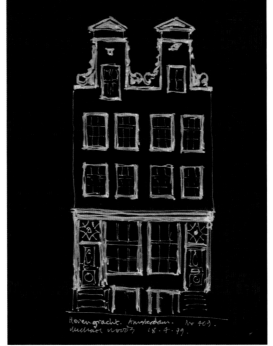

Advance Planning

REGULIERSGRACHT, AMSTERDAM, HOLLAND, 1999

- 20 x 13cm/8 x 5in • WHITE INK ON BROWN 150g/m²/70lb PAPER • 20 MINUTES

HERENGRACHT, AMSTERDAM, HOLLAND, 1999

- 20 x 10cm/8 x 4in • WHITE INK ON DARK BLUE 150g/m²/70lb PAPER • 15 MINUTES

SINGEL, AMSTERDAM, HOLLAND, 1999

- 20 x 5cm/8 x 2in • WHITE AND BLACK WATER-RESISTANT INK ON BROWN 150g/m²/70lb PAPER
- 15 MINUTES

PRINSENGRACHT, AMSTERDAM, HOLLAND, 1999

- 23 x 13cm/9 x 5in • BLACK WATER-RESISTANT INK, WATERCOLOUR ON BOCKINGFORD 425g/m²/200lb PAPER • 30 MINUTES

HERENGRACHT, AMSTERDAM, HOLLAND, 1999.

- 28 x 10cm/11 x 4in • BLACK WATER-RESISTANT INK, WATERCOLOUR ON BOCKINGFORD 425g/m²/200lb PAPER • 30 MINUTES

Canal-side houses, Amsterdam

Sketchbooks and drawing materials can be specially selected for some subjects and this can be particularly helpful when making the first drawing at a new site. I planned a first visit to Amsterdam feeling that I knew what it would be like. There are a lot of Dutch echoes in Norfolk architecture and I was familiar with paintings by Dutch masters. Again, holiday brochures and guide books gave a rough idea as to what to expect, and I gave some consideration to how I might draw the architecture. It soon appeared that many of the facades were quite dark in tone, while the window frames were white. In fact, because the buildings lining the canals are tall but very narrow, the windows become a dominant characteristic: drawing only the windows almost portrays the house. I prepared my loose leaf sketchbook with dark toned paper, brown and blue, as well as white, and filled one of my Rotring Art pens with white ink.

I made my first drawing (Reguliersgracht) on brown paper, just as it started to rain! Holding a small umbrella and my sketchbook with one hand, I was glad that the pen in the other was self-contained. I made two more drawings (Herengracht and Singel), the third one using white and black ink, feeling that my earlier preparations had been worthwhile.

I soon began to appreciate that variations in

Prinsengracht Amsterdam —
michael wood 19.4.99

wall colours added much to the individual character of a house. The issue of colour is where photographs and book reproductions of photographs can prove unhelpful and frequently inaccurate when used as a source of information. Film may have limitations regarding its sensitivity to certain colours and lighting conditions, and if the photograph is printed on paper, a further set of changes can come about. So if subject development is planned, I never use photographs but rely on my own sketchbook studies.

The weather improved and watercolour was not a problem. I found that to draw the strongest pattern I needed to be on the opposite side of the canal to the building. This brought about some snap decisions at bridges. In the two sketches using watercolour I laid in the washes using square-ended sable brushes. These work particularly well in making rectangular marks for panes of glass.

Animals

*Below: Seals
Bottom left:
Cats Emma and
Shuki Ting.
Bottom right:
Black widow tetra.*

I suppose I tend to draw animals when I am surprised by them. They often have fascinating shapes and wonderful colours but can be quite infuriating when they move and turn round – critical for me when I do not know their shape and am drawing them to find this out!

SEALS, C.1990
• 20 x 25cm/8 x 10in • BLACK WATER-SOLUBLE INK ON BOCKINGFORD 425g/m^2/200lb PAPER
• 10 SECONDS EACH

There are a fair number of seals round the Norfolk coast and, in walking the shoreline, it's quite common to have a staring match as they come in close. At Blakeney Point local fishermen take visitors to view the seals reclining on the sands. I made these drawings sitting with 20 other holiday-makers in a fishing boat about 25m/80ft off the beach. Each drawing could only take a few seconds but I covered three or four sheets. This sort of situation is a good example of when a larger sketchbook size has an advantage over a smaller one because there is less time taken up with page turning. The thick paper also meant that it kept flat in the blustery conditions.

EMMA AND SHUKI TING, C.1968
• 10 x 15cm/4 x 6in • BLACK WATER-SOLUBLE INK ON SMOOTH PRINTING PAPER • 20 MINUTES

I made this drawing about 35 years ago and it was the way the two cats were curled up together that made the drawing worth making. Domestic animals can become a natural part of the family and their habits commonplace. But now and then

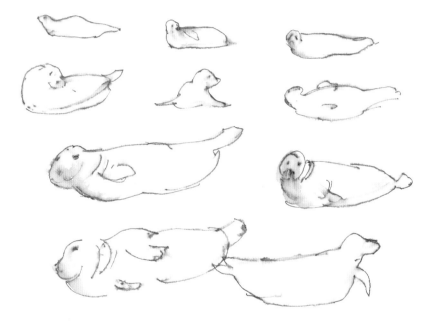

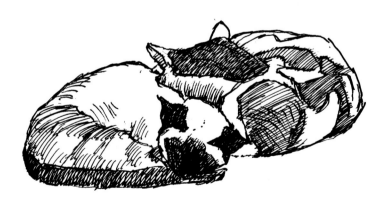

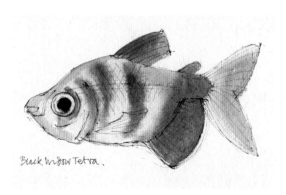

Black widow Tetra.

they produce something new, as here, where the single joining boundary has to become two cats.

BLACK WIDOW TETRA, C.1990
• 13 x 20cm/5 x 8in • BURNT UMBER WATER-RESISTANT INK, WATERCOLOUR ON HAND-MADE INDIAN PAPER IN BOUND SKETCHBOOK • 10 MINUTES

Aquariums are excellent places to study, particularly if you avoid the high season crowds. Fish are naturals at posing and even if they circle around a large tank they frequently return to much the same place. It's a very curious exercise assembling the characteristic shapes of one fish. If there is a shoal of one type it is possible to draw one from the parts of many. But it doesn't take long before you start to recognize a particular favourite and focus your drawing process on just that one. If a fish is very small, only 5–6cm (2–3in) long, it is worth drawing an enlarged version. It allows freer drawing and colour wash application.

BLUE CROWNED PARROTS (CONURE) C.1990
• 15 x 10cm/6 x 4in • BROWN WATER-RESISTANT INK, WATERCOLOUR ON WHATMAN 300G/M2/140LB PAPER • 10 MINUTES

These two birds were in a nature park and I could get quite close to them. They remained quite still while I worked. I thought the colours lovely, and watercolour suitable to record it, because if used freely and without overworking it can have a freshness that goes some way to describing the delicate quality of the feathers.

However, not all birds are as considerate as these two, and the experience of trying to draw the shapes and proportions of many of them can give marvellous practice in working quickly and having the right materials instantly to hand in order to do so.

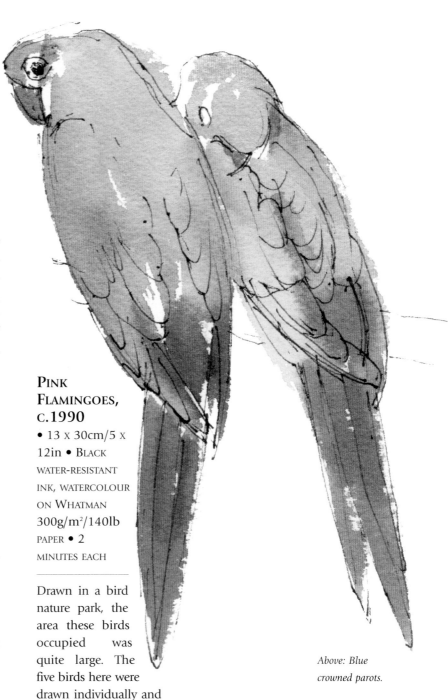

Above: Blue crowned parots.

PINK FLAMINGOES, C.1990
• 13 x 30cm/5 x 12in • BLACK WATER-RESISTANT INK, WATERCOLOUR ON WHATMAN 300g/m²/140lb PAPER • 2 MINUTES EACH

Drawn in a bird nature park, the area these birds occupied was quite large. The five birds here were drawn individually and were never in this arrangement at one moment. I simply started at the left and selected a first subject. According to their range I placed their feet roughly as I saw them – so the second one is further away. Drawing with a fine pen there was

*Right: Pink
flamingoes.
Below:
Whooper swan.
Opposite:
Princess Leya,
the pet hen.*

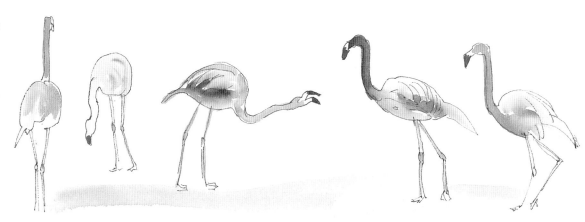

only one chance for each line. I changed to watercolour and from general observations applied the colours equally directly.

WHOOPER SWAN, C.1996

● BOTH 10 x 10cm/4 x 4in ● BLACK WATER-SOLUBLE INK ON BOCKINGFORD 425g/m^2/200lb PAPER ● 30 SECONDS EACH

These three little drawings were made in a wild life park. I had never before drawn a Whooper Swan with the yellow patch on its bill. Swans are good subjects because their movements are quite calm and they tend to stay doing one thing long enough to get a drawing completed.

PRINCESS LEYA, 1995

● 36 x 25cm/14 x 10in ● WATER-SOLUBLE BLACK INK AND SPIT ON HAND-MADE INDIAN PAPER ● 5 MINUTES EACH

These studies were made indoors of a family pet who was allowed to roam free on special occasions.

Making more than one study on the same sheet of paper has the advantage of reducing the chance of frightening the bird with the noise of rustling pages.

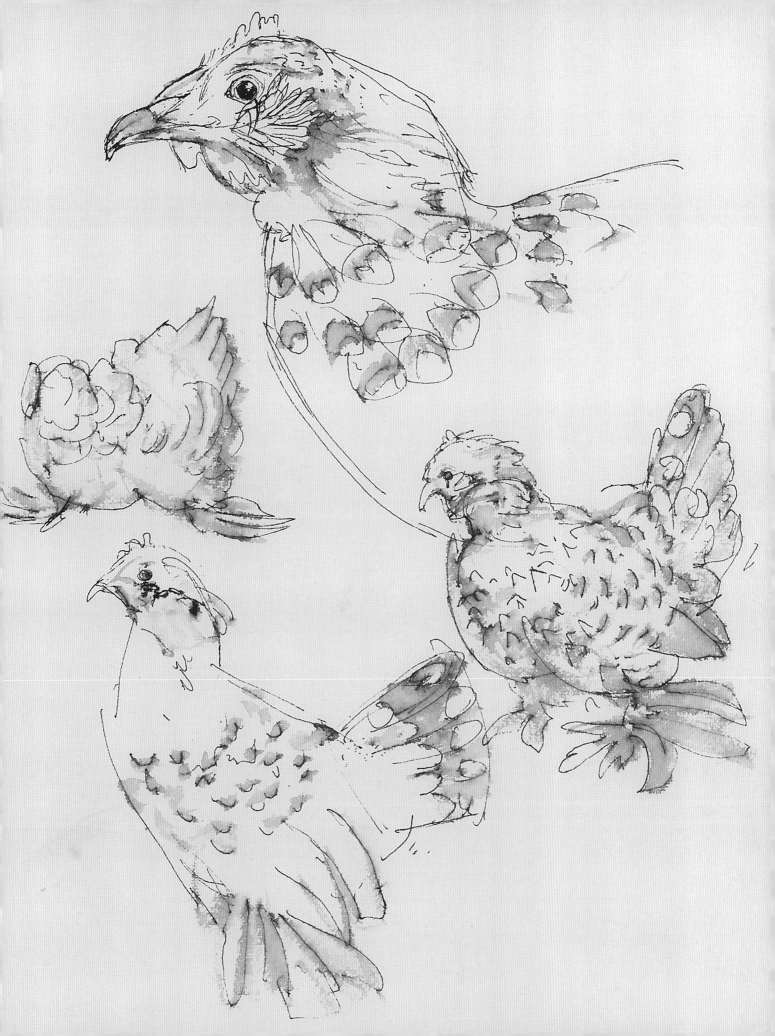

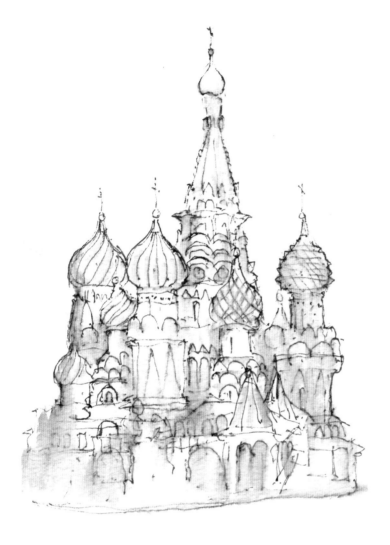

Sketching in Winter

St Basil's Cathedral, Moscow, Russia, 1999
- 23 x 15cm/9 x 6in • Black water-soluble ink on Bockingford 425g/m²/200lb paper
- 20 minutes

To have heard so much about Moscow and to have seen so many images of Red Square, I could hardly believe it when I was actually standing there. We were having a morning's guide before being free to go where we chose. It was mid November and bright but very cold, with the first winter snow falling. I suddenly realized that while our guide was talking, I could draw the Cathedral. It was quite a rush but I did complete it before dashing back to the coach.

St Basil's Cathedral, Moscow, Russia, 1999
- 10 x 10cm/4 x 4in • Black water-soluble ink, white pencil on grey 150g/m²/70lb paper
- 10 minutes

Later the same day, as the light was fading, I did another sketch across the whole length of Red Square. Weeks later in my studio I used these two drawings as reference for some paintings, but I was not satisfied with the results.

Snow in England, 2000
- 48 x 33cm/19 x 13in • White wax pencil on grey 150g/m²/70lb paper • 20 minutes

Twelve months on I was working in my studio when I noticed that it had started to snow and the flakes were particularly large. It was dusk and the snowfall had deadened all sound. I grabbed my largest sketchbook and selected a mid grey sheet and a white pencil and drew the

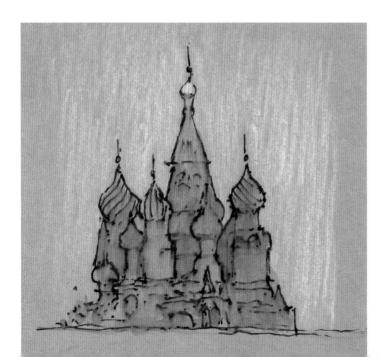

flakes falling. I had never drawn just snow before. The biggest flakes seemed to have a rather pointed centre, and there were veins or lines of flakes falling giving some sideways directions as well as downward. When I stopped it struck me almost immediately that here was the solution for my Moscow paintings. I had needed real information about snow.

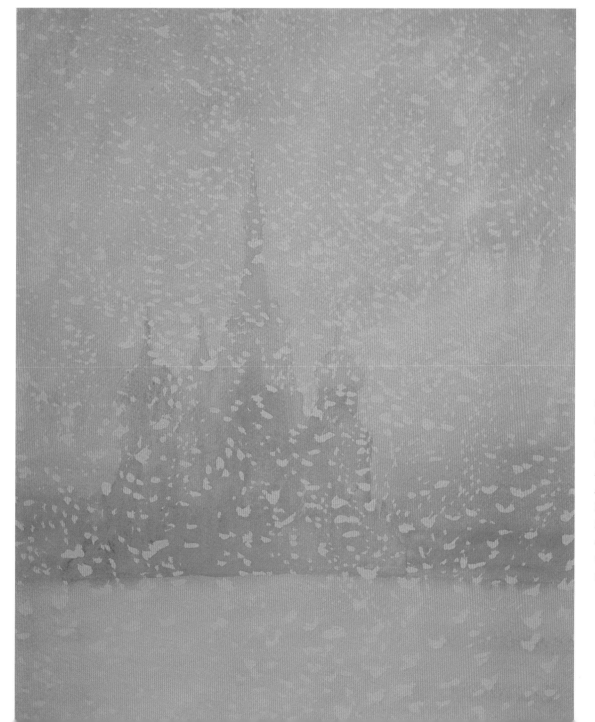

Opposite: two studies of St Basil's Cathedral, Moscow.
Above: Snow in England.
Left: Painting of St Basil's Cathedral in the snow.

Cathedral of the Archangel

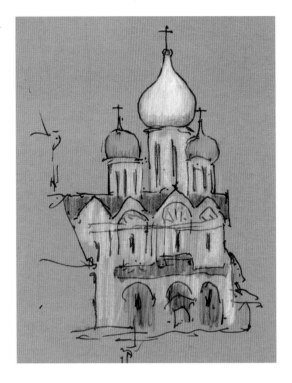

Novodevichy Convent and Gate Church

Opposite: Dome of St Basil's Cathedral

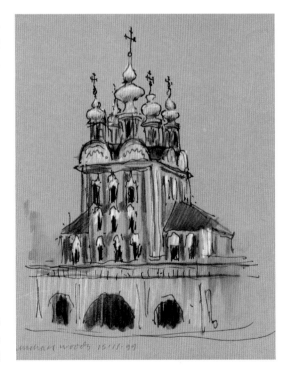

St Basil's Cathedral, Moscow, Russia, 2000

- 48 x 38cm/19 x 15in • Watercolour on Bockingford 425g/m²/200lb paper
- approximately 2 hours

So then I got out the Moscow sketches and, with the new snow drawing, painted a new composition. The first stage used rubber masking fluid to paint the snow flakes. Once that was dry I washed the whole area with the very gentle blue greys and buff purple of the sky and ground. While this was still wet I laid in the form of the cathedral. When all was dry, I removed the dry rubber masking the snow and returned them to bare white flakes.

Cathedral of the Archangel, The Kremlin, Moscow, Russia, 1999

- 15 x 8cm/6 x 3in • Black water-resistant ink, coloured pencils, on grey 150g/m²/70lb paper
- 5 minutes

The Kremlin is a wonderful mixture of architecture. This Cathedral looked good from across the river: I liked the two silvery-grey domes contrasting with the larger gold one. Our departing coach terminated the drawing.

As the days passed, the air temperature dropped several degrees below freezing. I find it difficult to draw while wearing gloves, so my hands were the first to react to the biting cold. Then my straight lines became rather wobbly and I first thought that my black pen had picked up a bit of grit on its nib. It took a few moments for me to realize that my ink was freezing! Thereafter I kept my pen in an inside pocket, but that hardly helped, so a few coloured and black and white pencils had to take over. Even standing still for more than 5 minutes hurt!

NOVODEVICHY CONVENT AND GATE CHURCH, MOSCOW, RUSSIA, 1999
• 15 x 10cm/6 x 4in • BLACK WATER-SOLUBLE INK, COLOURED PENCILS, ON GREY 150g/m²/70lb PAPER
• 10 MINUTES

I loved the cluster of domes on this building – an entrance gateway and a church. Again it had to be a very quick drawing and I found the quite complex arrangement of shapes and proportions difficult to sort out against a time limit. I only had a selection of coloured pencils with me and so colours had to be the nearest I could achieve. But I felt that the most important quality I should try to get down was the spirit of the design. There is much to be gained if right from the beginning you realize that you cannot fiddle with small elements: the whole shape must hang together.

ONE DOME OF ST BASIL'S CATHEDRAL, MOSCOW, RUSSIA, 1999
• 20 x 10cm/8 x 4in • COLOURED PENCILS ON GREY 150g/m²/70lb PAPER • 15 MINUTES

Very fine snow was falling and I knew that I had time for one last drawing. I decided on a single dome with its fresh layer of snow. My few coloured pencils had to be the means as the temperature was a long way below freezing. In fact, this was an advantage because the snow did not melt as it landed on my drawing. The shapes of the spiral elements of the dome were more complex than I had first thought and I took some time to work out the subtle directions.

Weeks later I made a lino cut from this drawing to see what effect I could get from using gold powder as a printing ink. I had also discovered that all the domes, now painted many colours, up until 1670 had been gold.

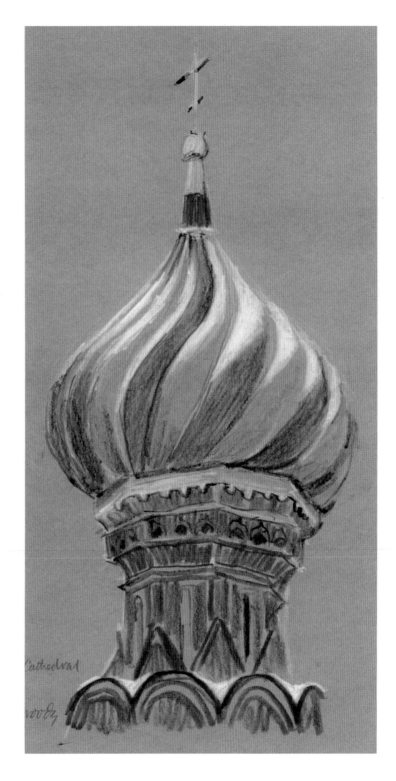

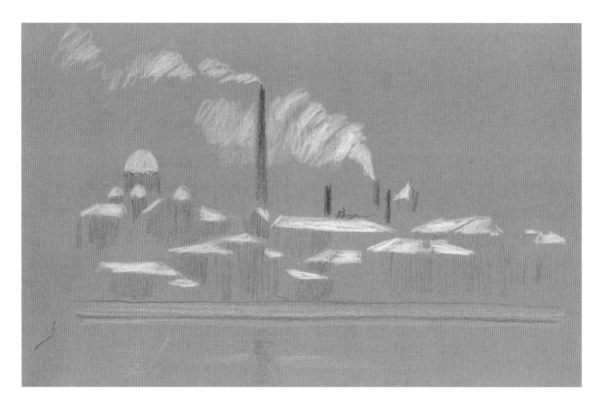

SNOW IN ST PETERSBURG, RUSSIA, 1999

- 15 x 20cm/6 x 8in • BROWN AND WHITE PENCILS ON GREY 150g/m²/70lb PAPER
- 5 MINUTES

Snow in St Petersburg

The Neva River was well on its way to being frozen and a morning's coach tour gave us a brief view of what could be visited in the following days. I do not know what this building was, but the snow-covered roof tops and the chimneys spilling their smoke across the sky made the group look very Russian.

PARK WITH NEW SNOW, ST PETERSBURG, RUSSIA, 1999

- 10 x 10cm/4 x 4in • BLACK WAX PENCIL ON BOCKINGFORD 425g/m²/200lb PAPER
- 5 MINUTES

Later that morning we stopped at a church, but it was part of a wooded park nearby that caught my eye. I'm not certain why it felt quite different to any other winter wood I had seen. I made the simplest little drawing with a black Karismacolor pencil.

NEW SNOW IN ST PETERSBURG, RUSSIA, 1999

- 38 x 38cm/15 x 15in • WATERCOLOUR ON BOCKINGFORD 425g/m²/200lb PAPER
- APPROXIMATELY 3 HOURS

Weeks later, back in my studio, I wanted to recreate the quality of that wood. I prepared a card template of the snow shape and I could use this to very lightly mark out the positions of the tree trunks. I could then get to this point several times. Using liquid rubber masking fluid, I protected the snow

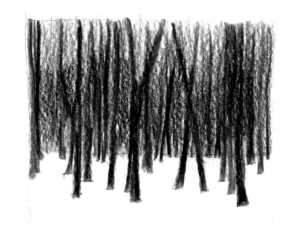

and when dry I was able to use watercolour for the trunks and the wood quite freely. When those washes were thoroughly dry, I lightly washed across the snow with clean water. It gathered a little pigment and created some shadows. Altogether there were five in the series, of which this is one.

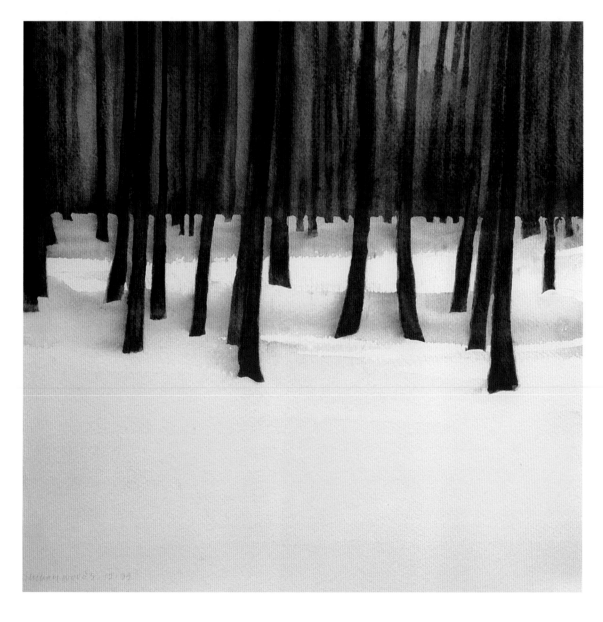

Above: Park with new snow. Left: New snow in St Petersburg.

*Above:
Farncombe
Station,
England.
Right: Albania
from Corfu.
Opposite: Blue
Cedar in snow.*

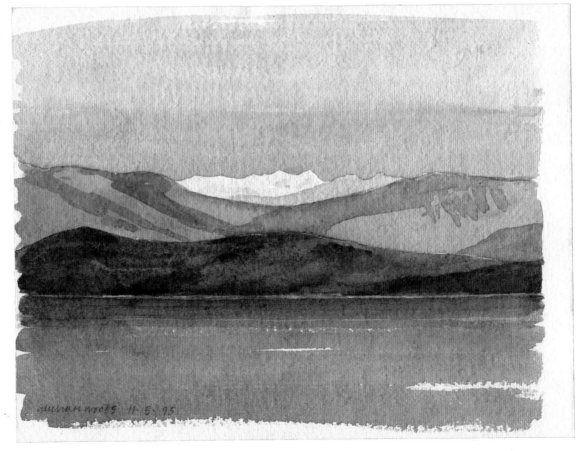

FARNCOMBE STATION, ENGLAND, 1966
- 13 x 28cm/5 x 11in • BLACK WATER-RESISTANT INK, 3B PENCIL ON SMOOTH PRINTING PAPER
- 20 MINUTES

Snow is one of those substances that can change surroundings extraordinarily quickly. A fine layer on roof tops can reverse tonal relationships completely. The fact that the sky can become dark and almost opaque makes white snow-shapes even more dramatic. Here Farncombe Station looks very bleak in mid winter.

ALBANIA FROM CORFU, 1995
- 18 x 23cm/7 x 9in • WATERCOLOUR ON HAND-MADE INDIAN PAPER • 20 MINUTES

Although the early evening was getting cool, it wasn't winter. Had I been up in the mountains, no doubt it would have felt quite icy. In fact I was sitting at the water's edge in Corfu looking across to Albania. In the distance the sun was catching a snow-clad mountain range. The sun had gone from everything else but the light on the snow gave the far distance a sense of great importance.

BLUE CEDAR IN SNOW, CHARTERHOUSE, GODALMING, SURREY, 1982
- 36 x 25cm/14 x 10in • WATERCOLOUR ON WHATMAN 300g/m²/140lb PAPER • 1 HOUR

Overnight snow had fallen heavily and early next morning the transformation was quite magical. From inside a building, but with a large window open, I had about an hour to paint this cedar in the hazy morning light. Almost before I had finished the sun's temperature had risen enough to start the first falls of melting snow. This sort of study is valuable in recording qualities that may last only briefly.

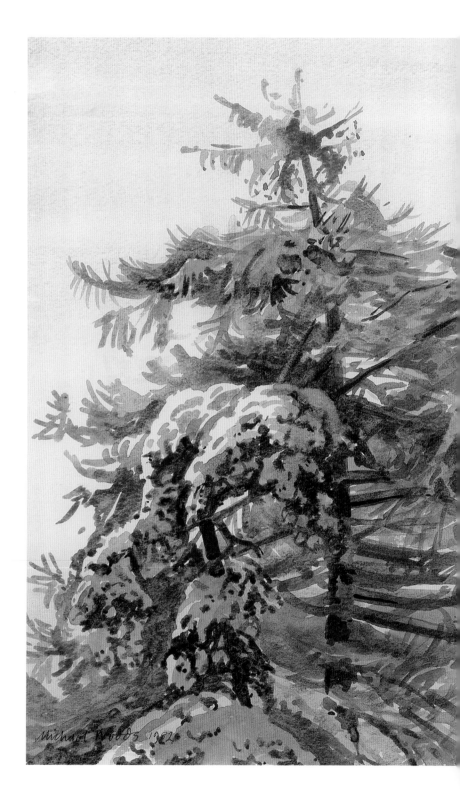

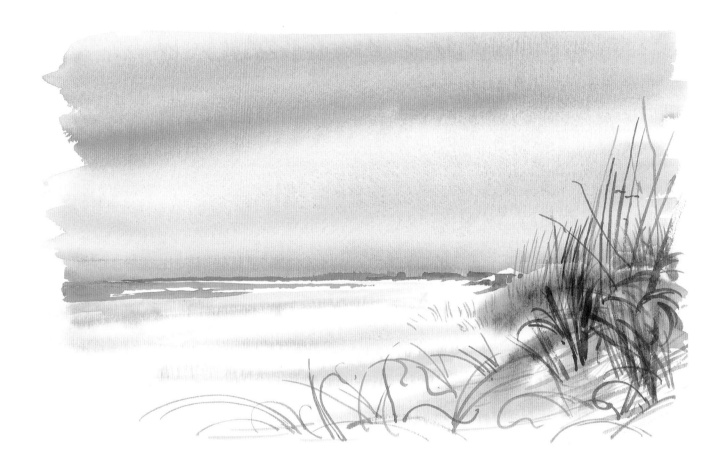

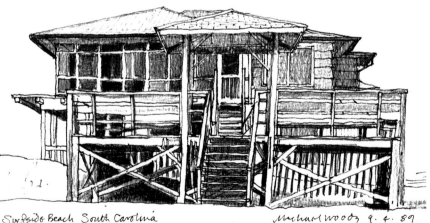

Surfside Beach South Carolina Michael Woods 9. 4. 89

Fresh Pastures

SURFSIDE BEACH, SOUTH CAROLINA, USA, 1989

- 23 x 33cm/9 x 13in • WATERCOLOUR ON WHATMAN 300g/m²/140lb PAPER
- 40 MINUTES

When I visit a city or a country new to me, I am often more surprised by the similarities in landscapes than the differences.

This watercolour of the beach near to where I was staying, could at first glance be any one of a number of places in East Anglia in England. But as I painted I realized there were many

subtle differences. The quality of the light was brighter in South Carolina; the sea was a much clearer blue and green. The beach was very pale, almost harshly bright, while the beach houses came right on to it. The sketchbook is ideal for recording things such as this.

BEACH HOUSE, SURFSIDE, USA, 1989
• 13 x 28cm/5 x 11in • BLACK WATER-RESISTANT INK AND 3B PENCIL ON WHATMAN 300g/m²/140lb PAPER • 30 MINUTES

This house was pale grey, sea weathered and sitting very comfortably in the sand dunes. I found it very enjoyable to draw because the way it had been built was quite visible. The soft 3B pencil gave some recession, space and shadow, and the paper's texture gave a worn quality as the pencil did not cover the hollows.

CACTUS, SOUTH CAROLINA, USA, 1989
• 20 x 30cm/8 x 12in • BLACK WATER-RESISTANT INK, WATERCOLOUR ON WHATMAN 300g/m²/140lb PAPER IN SPIRAL BOUND SKETCHBOOK
• 40 MINUTES

Walking in a residential area, I was quite surprised to come across this clump of cactus gracing a front garden, and fascinated that it had so many greens in its make-up.

Looking at it now I can see that the pen line is hardly functioning, and I suspect that the ink had dried up during the heat of travel. I use a converter in most pens as it can be washed out and refilled easily, but the supply channels to the nib need washing thoroughly as well. Any ink will dry and cause a block, but those which, when dry, are not dissolved by water make the most problems.

Opposite top: Surfside Beach, South Carolina. Opposite below: Beach house, Surfside. Left: South Carolina cactus.

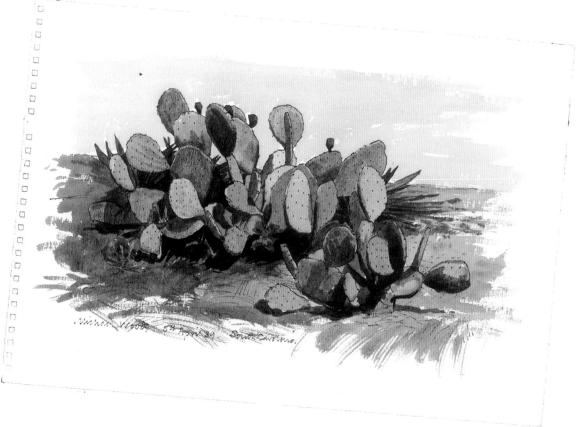

Right and below: Cley. Bottom: Clouds over Russia. Opposite: Alps in cloud.

Cley on Alex's birthday .

Chasing Clouds

CLEY ON ALEXANDRA'S BIRTHDAY, AUGUST 1999

- 15 x 13cm/6 x 5in AND 13 x 15cm/5 x 6in
- BLACK WATER-SOLUBLE INK ON ARCHES AQUARELLE HP 300g/m²/140lb PAPER • 5 MINUTES EACH

There are some moments when it is possible to feel very close to the workings of nature. A family party had been to the coast for a birthday celebration but the weather was deteriorating. As we arrived back at the car, rain started to fall a couple of miles away so we watched as it moved towards us. It was particularly vivid and the clouds looked really heavy with the water cascading out of them. Some sketchbook drawings have to use a kind of mark language. The marks may describe something happening but in a sort of translated form. Fresh problems can arise when these need to be re-translated into a more developed form, as in full colour.

CLOUDS OVER RUSSIA, 1999

- 13 x 15cm/5 x 6in • WHITE AND BLUE PENCILS ON GREY 150g/m²/70lb PAPER • 10 MINUTES

Looking down on clouds from a plane can show up their grouping quite clearly. The observation of their shape has to be as much a reaction as a construction. The process is to look at the clouds and follow your understanding through your hand but without actually looking at the drawing all the time. It is more important to get the quality of the shape right rather than the actual parts for there is simply not enough time. The view through a plane window is quite limited. So if I want to draw, I find I must be ready and waiting, paper and pencil poised. Drawing something that is pale all over, with a pencil that makes a dark line, tends to mean that

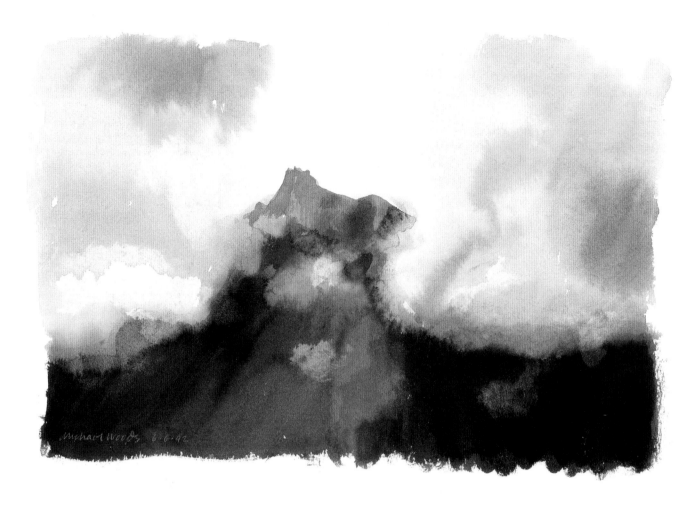

an edge line is created and the space beyond the object – here the cloud – has to be made dark to make the cloud look pale.

In this drawing I made the white clouds with a white pencil; the shadows on the ground were drawn with a blue one. What seems to me curious is the closeness of the clouds to the ground, compared with the height of the plane above the clouds.

ALPS IN CLOUD, FRANCE, 1992
• 23 x 33cm/9 x 13in • WATERCOLOUR ON WHATMAN 300g/m²/140lb PAPER • 20 MINUTES

I made several paintings of this mountain from our camp site far below it. It kept appearing and disappearing in a rather alarming way, so at good viewing times I had to react very quickly.

At the busiest moment just about the whole painting was wet and in order to keep the clouds hazy and semi transparent I lifted off some of the watercolour wash with pieces of absorbent paper towel.

Having once got a record of some relatively simple shapes, this sort of sketch can be re-tried in the studio where the moment of dryness or wetness can be judged much more subtly.

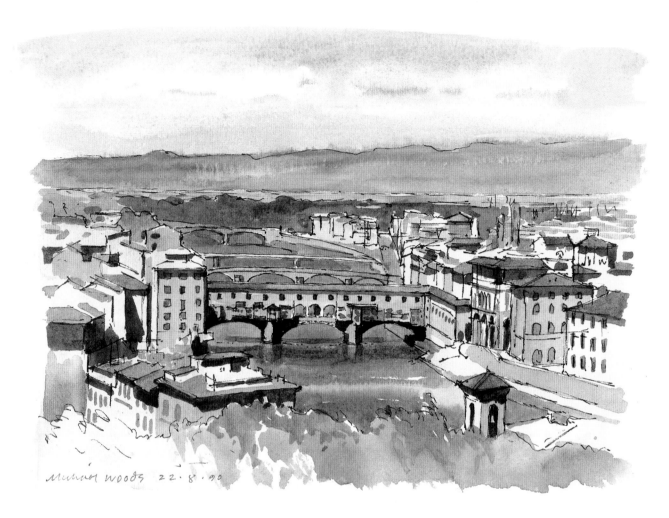

Michael Woods 22.8.90

Holiday City

The Arno in Florence

Visiting a city several times means that one begins to understand its layout, its special characteristics, its colours and its sounds. I expect that I have visited Florence more times than any other holiday destination – well, for one in the art business, this is not very surprising. But I still feel that I know too little about it and when I draw I am only slowly unravelling the many decisions, proportions and structures that architects and painters have made and that have set such a store of standards.

THE ARNO IN FLORENCE, ITALY, 1990
• 20 x 25cm/8 x 10in • BURNT UMBER, WATER-RESISTANT INK, WATERCOLOUR ON WHATMAN 300g/m²/140lb PAPER • 40 MINUTES

This is one of the classic views of Florence. The River Arno makes its way through the city quietly in summer, but the winter flow can be massive. The Ponte Vecchio is central with its jewellery shops, and above them a corridor linking the Pitti Palace – out of the picture on the left – with the Uffizi Palace on the right. I do not find Florence beautiful in the grand or

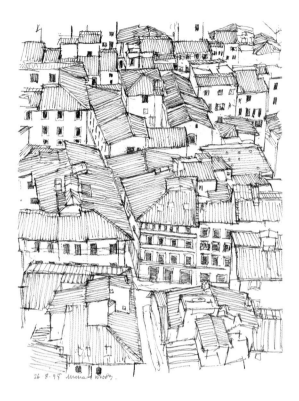

26.8.98 *Irina & Wood*.

the picturesque sense, although it does have parts that are both of these, but it seems to have a deeply felt presence – a great dignity – where almost everything seems considered. So, although I had drawn this view before, I just had to tackle it again, particularly as it was a lovely clear morning and there were some strong shadows. Having drawn the main shapes and areas with a warm brown, I put a creamy wash over all the parts that were buildings, and the foreground trees as well. This immediately had a unifying effect but it did not limit the placing of darker tones to strengthen various walls and roofs.

ROOFS OF FLORENCE, ITALY, 1998
• 36 x 25cm/14 x 10in • BLACK WATER-RESISTANT INK ON BOCKINGFORD 425g/m²/200lb PAPER • 40 MINUTES.

LINOCUT, 1999
• 16 x 13cm/6¹/₂ X 5in • PRINTED ON CARTRIDGE 150g/m²/70lb PAPER

I took this view of the tiled roofs from the top of the Cathedral's dome.

Later, from this drawing, I made a linocut. The translation from the directional lines of the tiles to the cutting of the smaller lino means that the texture has to be much coarser. However, this also has the effect of making the image a tougher, stronger pattern.

Left: Roofs of Florence.
Below: Linocut.

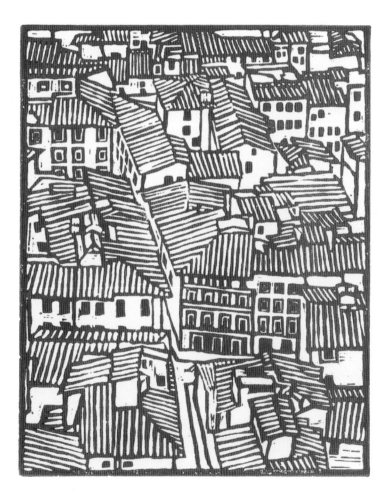

PORCINI EXTRA, FLORENCE, ITALY, 1998
- 15x 13cm/6 x 5in • BLACK BRUSH PEN, WHITE PENCIL ON BROWN PAPER • 10 MINUTES

PORCINI EXTRA PRINT, 1999
- 15 x 13cm/6 x 5in • 2 COLOUR LINOCUT, CARTRIDGE 150g/m²/70lb PAPER

While shopping in the great covered market near S. Lorenzo, I saw a marvellous collection of mushrooms for sale. One tray of what was called Porcini Extra I couldn't resist. I decided on the best area of the tray and, on dry brown paper, used a brush pen containing black ink that allowed me to work quickly. Some indication of paler areas, a little modelling with a white pencil, and it was complete.

A few months later I made a linocut working at the same size as the sketchbook drawing. The brown was printed first, with the white being the paper itself, and the second block printed the black.

Porcini Extra, drawing and print

THE UFFIZI, FLORENCE, ITALY, 1998
- 20 x 25cm/8 x 10in • BLACK WATER-RESISTANT INK, WATERCOLOUR ON BOCKINGFORD 425g/m²/200lb PAPER • 1 HOUR

Although I had always wanted to draw the Uffizi, I had never been in the right place at the right time. I was walking along the south side of the Arno with two members of my family when I suddenly noticed that the Uffizi Palace facade was directly across the river. The day was bright, the others wanted to shop, so here at last was my opportunity.

This sort of study involves some understanding of proportion; the great catch is to decide how and where to start. For me, to draw the outside boundary and then try to sub-divide it, simply does not work. The parts might be nameable, but their individual proportions would be wrong. Yet, if a start is made in the centre and drawing expands outwards, the overall proportion may itself be wrong. I

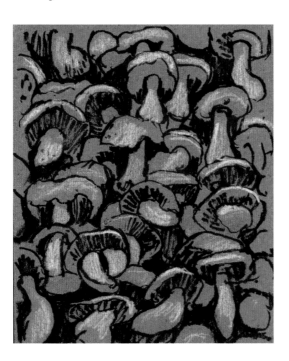

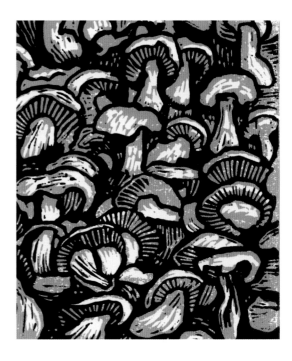

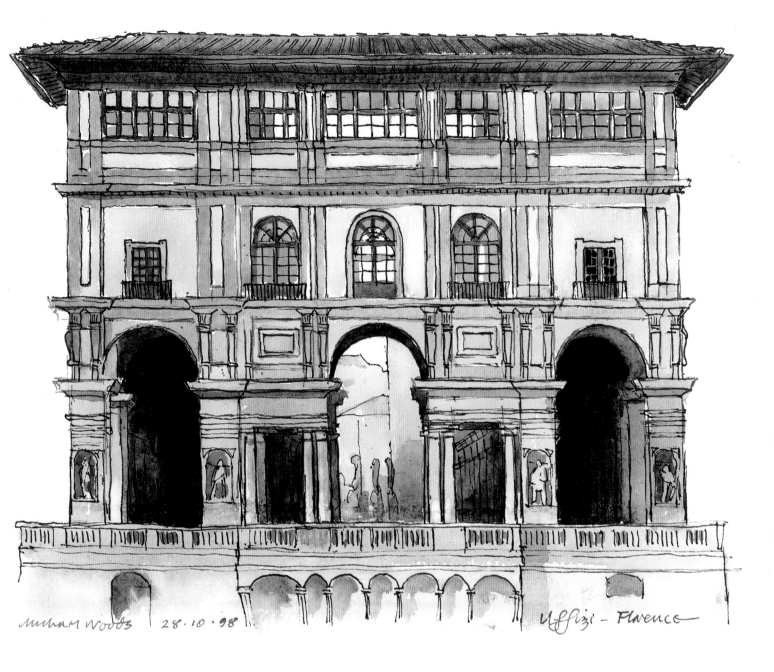

Michael Woods 28·10·98 Uffizi – Florence

decided the solution for this subject was to draw one central horizontal faintly. (A pen nib used upside down will usually make a fine line.) A few dots will indicate where a line will be added later. The other horizontals above and below can then be considered. The vertical divisions, which in this building are quite strong, can be placed with some slight marks and dots. Once four boundaries or their faint possibility come together, an area with a particular proportion comes about. It is at this stage, not a wall or a window or a pilaster, but lines in a relationship with other lines. Once that critical set of relationships is thought to be as accurate as it can be, then they can indeed become areas of wall or an opening. Because I was only thinking about this facade, I decided not to become involved with the buildings either side. I wanted to see what Vasari had planned for just this alone.

The Uffizi,
Florence

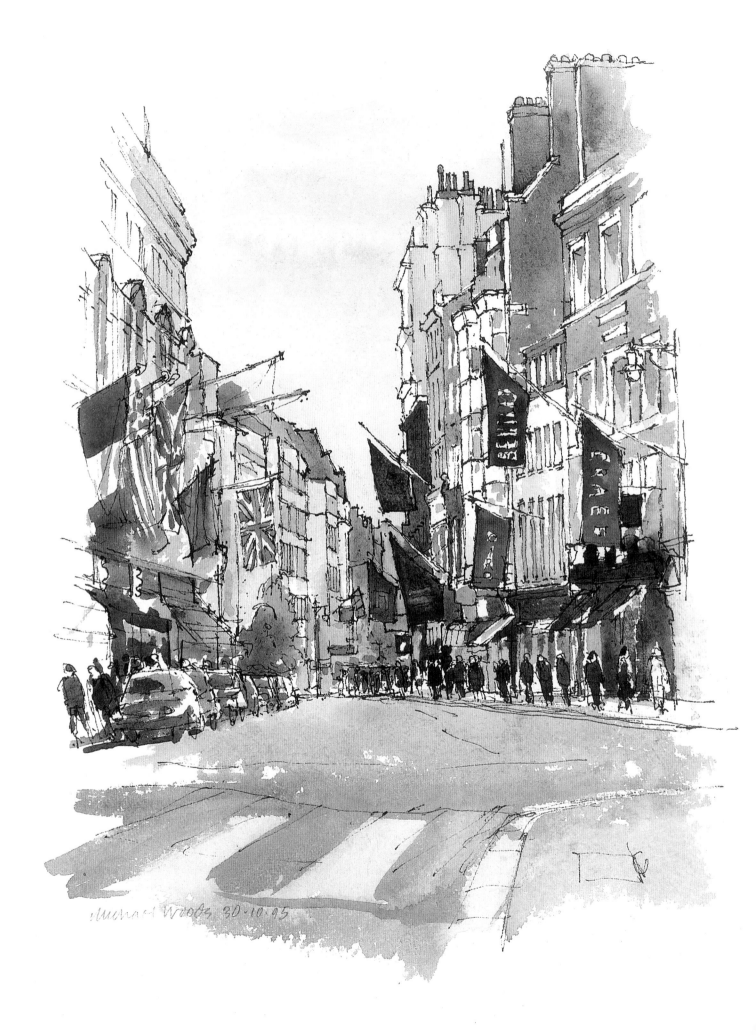

Michael Woods 30·10·95

London

I love London and I've drawn there a lot. It is a richly woven mixture of buildings and landscape, textures and colours.

NEW BOND STREET, LONDON, ENGLAND, 1995

• 30 x 23cm/12 x 9in • DARK BROWN WATER-RESISTANT INK, WATERCOLOUR ON HAND-MADE INDIAN 300g/m²/140lb PAPER • 1 HOUR

I had to be in London for a meeting but had a free hour in the afternoon when I was in Bond Street. It was the end of October and I knew that the light would begin to drop. It is quite possible to draw just structure and hardly be concerned about changes in light and weather conditions, but as soon as tone and colour, space and light are involved, the span of painting time becomes quite critical.

Although this view looks complicated, it is in fact divided up in a number of simple ways. The sky makes the building shapes and the buildings make the sky shape. Early on I realized that it was important to check the relationship of major parts from one side of the road to the other. For example, the second building from the right has three window or floor levels above the ground floor shop. But so has the building to its right, and so has the building on the left side of the picture. But they are not all the same height. The flags and flag poles give useful marker points, and the people and parked cars give scale and describe the space as the road slopes slightly downwards and travels away.

A delivery van parked on the right hand side for about a quarter of an hour but it must have heard me muttering and eventually left. That sort of thing can be a problem in busy towns and cities, so it can be wise to develop potential

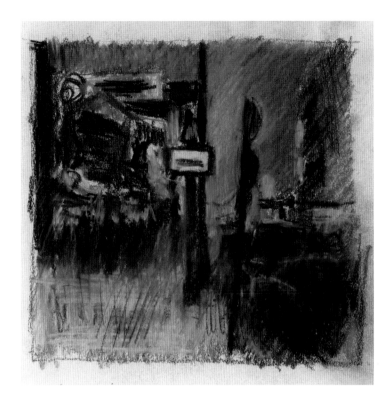

trouble areas while they are clear, and be prepared to shift to other parts of the drawing when obstructions occur.

TOWARDS PICCADILLY CIRCUS, LONDON, ENGLAND, 1959

• 18 x 18cm/7 x 7in • COLOURED CHALKS ON CARTRIDGE 150g/m²/70lb PAPER • 40 MINUTES

London or indeed any city can be very dramatic at night. I used to use chalks quite often because they do have the advantage that the colours can be worked and softened into one another. On the other hand they can be very messy and in low light small used sticks of colour are difficult to identify. The drawing needs fixing as soon as possible – in this sketch you can see the spread of pigment dust, particularly at the top and bottom right. But for this sort of subject they can convey a good sense of atmosphere.

Opposite: New Bond Street, London

Above: Towards Piccadilly Circus, London

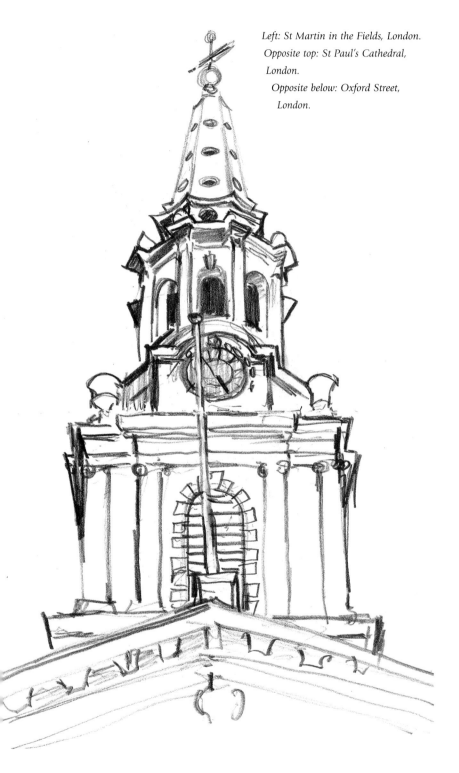

Left: St Martin in the Fields, London.

Opposite top: St Paul's Cathedral, London.

Opposite below: Oxford Street, London.

ST MARTIN IN THE FIELDS, LONDON, ENGLAND, 1975

• 36 x 23cm/14 x 9in • 6B PENCIL ON SMOOTH CARTRIDGE IN BOUND BOOK • 10 MINUTES

I had been to see an exhibition in the National Gallery in Trafalgar Square with about 50 of my pupils. I suspect that we had come outside to meet up with our coach, which would be leaving at 5 o'clock, and looking at the clock face now it seems to be just 7 minutes to!

I have always found that however much I enjoy seeing a wonderful exhibition of superb paintings, it is the moment I come out into fresh air that I feel recharged and want to draw. The National Gallery is wonderfully situated, for the main portico is well above the square and fountains, and Whitehall is directly ahead, leading to Big Ben. To the left is St Martin in the Fields, and I am still impressed how it holds its place with such dignity. I probably had no more than 10 minutes to make a statement about James Gibbs's design. The pencil was getting flatter by the minute as I thumped down the lines.

Months later it became a silk screen print.

OXFORD STREET, LOOKING WEST, LONDON, ENGLAND, 1956

• 18 x 13cm/7 x 5in • BLACK WATER-SOLUBLE INK ON CARTRIDGE 150g/m²/70lb PAPER • 1½ HOURS

I made this drawing when I was a student at the Slade School of Art. It was the first stage towards a composition with figures. I used to go exploring at weekends, when London was so much quieter than it would be now. When a lot of people are passing buildings it is surprisingly difficult to see, and thus draw, the lower parts. For some studies it is therefore very important to choose quiet times.

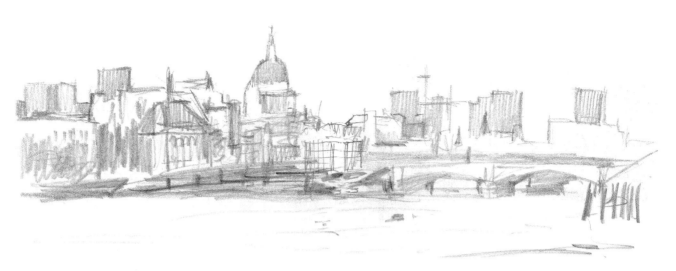

St Paul's Cathedral Across the Thames, London, England, c.1972
• 15 x 33cm/6 x 13in • 4B pencil on smooth cartridge paper in bound book • 15 minutes

I think this drawing was made in the early 1970s, but I can only date it from other drawings in the sketchbook. I now try to date drawings more conscientiously and sometimes name the site, either right at the edge of the paper or on the back. It is surprising how quickly drawings take on an historical character. I suspect that I drew from Waterloo Bridge looking towards the City of London, with St Paul's Cathedral still standing above everything else, and Blackfriars Bridge spanning the Thames. The cranes are building the tall blocks of the city. This sketch was a first thought for a view that was to be a large commissioned painting. Over this drawing conversations were had and the job went ahead.

Notice I selected a page spread with only stitching down the fold line.

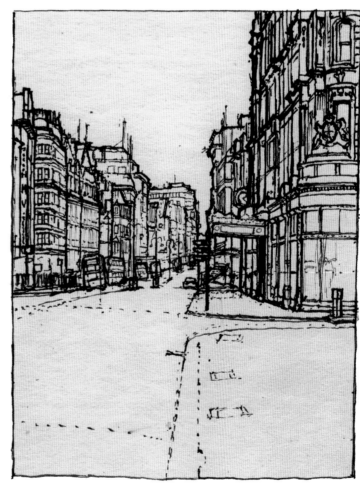

Right: London
Coliseum.
Below: Tower
Ballroom,
Blackpool,
England.
Opposite:
Bolshoi Theatre,
Moscow.

BALFE

Interiors

The exterior façade and the entrance ways of a
theatre rarely reveal what the auditorium will
look like, so I can never tell how I am going to
react to it. I am always delighted because I feel
that 'theatre' starts there, and not just when the

performance begins, so I try to get to my seat perhaps 15 minutes early so that I have time to look and possibly draw. My 13 x 18cm/5 x 7in sketchbook sits comfortably in most of my pockets and a couple of pens and a field brush cause no problems.

LONDON COLISEUM, ENGLAND, C.1990
• 20 x 20cm/8 x 8in • BROWN WATER-SOLUBLE INK ON CARTRIDGE 150g/m²/70lb PAPER • 15 MINUTES

The seat allocated dictates the drawing position. I rather like this control because it means that I do not have to choose, and drawings take what time is available. The time prior to the performance is by far the most productive.

TOWER BALLROOM, BLACKPOOL, ENGLAND, 1998
• 18 x 13cm/7 x 5in • BLACK WATER-SOLUBLE INK ON FABRIANO WATERCOLOUR 280g/m²/130lb PAPER
• 15 MINUTES

Ballroom dancing was under way to the sounds of the theatre organ when I arrived and the elaborate forms of the balconies were very impressive. Because there was no actual performance I felt much more relaxed.

BOLSHOI THEATRE, MOSCOW, RUSSIA, 1999
• 28 x 13cm/11 x 5in • BLACK WATER-SOLUBLE INK ON FABRIANO WATERCOLOUR 280g/m²/130lb PAPER
• 15 MINUTES

In the Bolshoi Theatre I was sitting in the stalls in a traditional wooden framed chair. The two boxes to my left were very grand and I had to use two sheets of paper to get the drawing reasonably complete. The darker interior of the box does much to show up the shape of the hanging draperies.

Above: Canon Alderson reading the paper.
Above Right: Bernard Leach, the potter.
Right: Alan Lees playing cards.
Opposite top: Jeremy Baines listening to music.
Opposite below: Tony Birks-Hay.

People

I've drawn and painted a lot of people over the years. In most cases I would not put the idea, or a preliminary drawing, of a portrait in a sketchbook. When people are involved, plans and arrangements tend to be made and the process becomes more formal with sittings and appointments for commissioned work.

I think the sketchbook study tends to happen when one is a student, or travelling, or listening to after dinner speeches, or the time when arrangements float and circumstances just occur.

CANON ALDERSON AT SALISBURY, C.1953

- 28 x 25cm/11 x 10in • 3B PENCIL ON CARTRIDGE 150g/m²/70lb PAPER • 30 MINUTES

I was a guest and my host was reading the paper before Sunday lunch. He was content to keep still for about 15 minutes and I then continued for a similar time completing the furniture.

ALAN LEES PLAYING CARDS, C.1953
• 23 x 13cm/9 x 5in • 2B PENCIL, WATERCOLOUR WASH ON THIN CARTRIDGE PAPER • 10 MINUTES

When others are doing something, as in this case playing cards, positions tend to stay for a time and are very often repeated. The pencil line is the continuous type taking only 2 or 3 minutes.

BERNARD LEACH, C.1957
• 13 x 15cm/5 x 6in • BLACK WATER-SOLUBLE INK ON CARTRIDGE 150g/m^2/70lb PAPER • 10 MINUTES

Bernard Leach, the potter, was guest of honour at a conference that I was attending. While he was answering questions, I made four drawings of him, of which this is one.

JEREMY BAINES, C.1956
• 23 x 28cm/9 x 11in • LITHOGRAPHIC CHALK, LITHOGRAPHIC PAPER, PRINTED ON TO INGRES BROWN PAPER • 30 MINUTES

A colleague at the Slade School of Art: we were listening to a symphony recording and I liked his long flopping position in the chair. I was testing lithographic paper and I printed it later.

TONY BIRKS-HAY, 1958
• 28 x 23cm/11 x 9in • BLACK WATER-SOLUBLE INK, 8B PENCIL ON CARTRIDGE 150g/m^2/70lb PAPER • 30 MINUTES

Another Slade colleague was sitting in a circular metal-framed wicker chair that was rather good for drawing purposes as it made the model sit in only one way. I am not sure how comfortable it was, because by the time I had got to developing the darker areas, I have a feeling that the vigour or the 8B pencil shows he was anxious for the drawing to terminate.

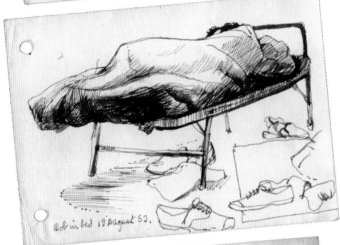

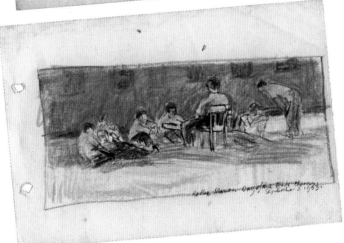

GINGER RESTING, 11 AUGUST 1952
• 10 x 14cm/4 x 5½in • BROWN WATER-SOLUBLE INK ON SMOOTH THIN CARTRIDGE PAPER
• 15 MINUTES

BOB IN BED, 19 AUGUST 1952
• 10 x 14cm/4 x 5½in • BROWN WATER-SOLUBLE INK ON SMOOTH THIN CARTRIDGE PAPER
• 15 MINUTES

PAUL OFF WATCH, 15 NOVEMBER 1952
• 10 x 14cm/4 x 5½in • BLACK WATER-SOLUBLE INK ON SMOOTH THIN CARTRIDGE PAPER
• 15 MINUTES

GROUP AT RUDLOE MANOR, 8 SEPTEMBER 1953
• 10 x 23cm/4 x 9in • BLACK WATER-SOLUBLE INK, COLOURED CHALK ON SMOOTH THIN CARTRIDGE PAPER • 20 MINUTES

Doing two years' National Service in the Royal Air Force brought me into contact with many people and places. Right from the start I was prepared to draw if the chance arose. I recognized that if I wanted to follow some sort of career in art, then I had to do a lot of finding out. In these sketchbook drawings I was starting to ask questions in strange surroundings, and finding how to use the small periods of time that became available.

STRAWBEAR FESTIVAL, WHITTLESEY, CAMBRIDGESHIRE, ENGLAND, 2002
WATCHING DANCER
• 21 x 10cm/8½ x 4in

CHICKEN
• 23 x 10cm/9 x 4in
• BLACK WATER-SOLUBLE INK AND SPIT ON BOCKINGFORD 425g/m²/200lb PAPER •
5 MINUTES EACH

On a bright but cold January day I was taken to this street festival by some friends. I carried my 25 x 36cm/10 x 14in sketchbook, with pens and a field brush in my pocket.

All the dancing groups wore special clothes, many of which were quite remarkable. Face make-up was also very bold, many with black or strong solid colours. I found that resting dancers were more possible to draw because they moved to the back of the watching crowds. I had imagined that I could draw the figures using mainly line to describe them. In fact tone was really the dominating characteristic, because of the strong make-up and costumes, and a brush pen might have been more versatile.

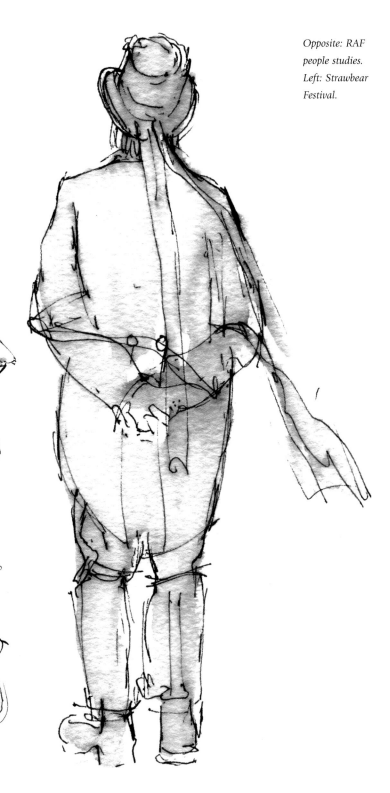

Opposite: RAF people studies.
Left: Strawbear Festival.

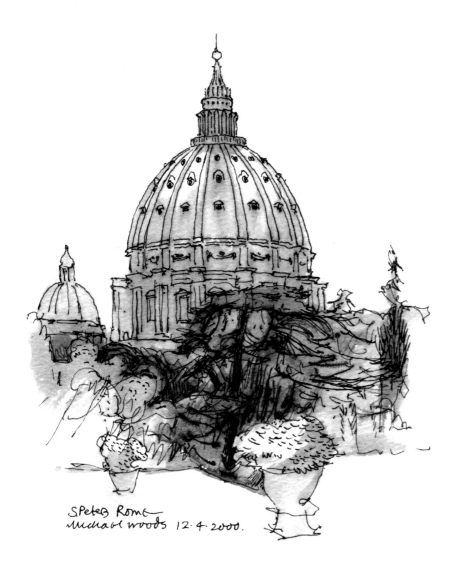

SPeters Rome
michael woods 12·4·2000.

Historic Architecture

St Peter's, Rome I have enormous respect for much of the architecture of Rome, and I enjoy visualizing what places such as the Forum would have looked like when all the buildings were standing. But the remains of walls, however vital in history, do not always draw well, and my reactions are more positive when I see a building in use, taking light and shadow. In Rome there are many.

ST PETER'S, ROME, ITALY, 2000
• 23 x 18cm/9 x 7in • HB PENCIL, BLACK WATER-RESISTANT INK, BLACK WATER-SOLUBLE INK ON BOCKINGFORD 425g/m²/200lb PAPER • 30 MINUTES

St Peter's is a huge building in a huge complex. Drawing domes is difficult and I'm not a very happy man if my domes are crooked or have the wrong profile. When I came out on to the terrace at the Vatican I had a determination to have another attempt at Michelangelo's Dome, which I have drawn several times before.

For a start the curvature has to be right, and the divisions spaced as the circle turns away. So I decided to do what I always advised my students not to do – I used an HB pencil to lay out the proportions and the intervals with dots and small marks. That done, I could then draw very quickly and freely with my black ink. Why I am usually against laying something out with pencil before drawing with pen and ink is that with most students the pencil drawing will be made almost complete. The ink line will then only copy what has already been drawn, and frequently this copy line will have very little spirit of its own. But, with experience, a few marks and dots can help a great deal in drawing volumes that do not want clumsy outlines. By the time I had got most of the drawing complete, the sun was precisely above the centre line of the lantern and dome, and so using another pen with water-soluble ink in it, and a brush with some water, I collected ink from the pen nib with the brush and applied a gentle tone. The nearby trees were very dark, but I only wanted to use them in order to make the dome seem much further away.

THE BALDACCHINO, ST PETER'S, ROME, ITALY, 1988
• 20 x 15cm/8 x 6in • BLACK WATER-SOLUBLE INK ON CARTRIDGE 150g/m²/70lb PAPER • 10 MINUTES

Years earlier I had drawn the Baldacchino with enthusiasm. A stunning structure by Bernini made out of bronze, and 29m/95ft tall, my pen chased over its form in 5 or 10 minutes, followed by a field brush wetted with spit to achieve the tones.

ST PETER'S SQUARE, ROME, ITALY, 2000
• 10 x 8cm/4 x 3in • BLACK WATER-SOLUBLE INK ON FABRIANO MURILLO 260g/m²/120lb PAPER
• 10 MINUTES

In St Peter's Square the Pope was giving an audience and thousands of people were present: I drew some standing by Bernini's Colonnade and being watched over by noble figures above.

EASTER DAY, ROME, ITALY, 1988
• 20 x 13cm/8 x 5in • BLACK WATER-SOLUBLE INK ON CARTRIDGE 150g/m²/70lb PAPER
• 5 MINUTES

My wife and I were leaving Rome at lunchtime but, as it was Easter Day, we walked to St Peter's Square to see the Pope. Sadly it started raining and time began to run out, but I made this very slight drawing from under our umbrella although, even so, five spots of rain still managed to hit the ink lines.

S·V·BVRGHESIVS·RŌ

Easter Sunday at St Peters Rome. April 1988.

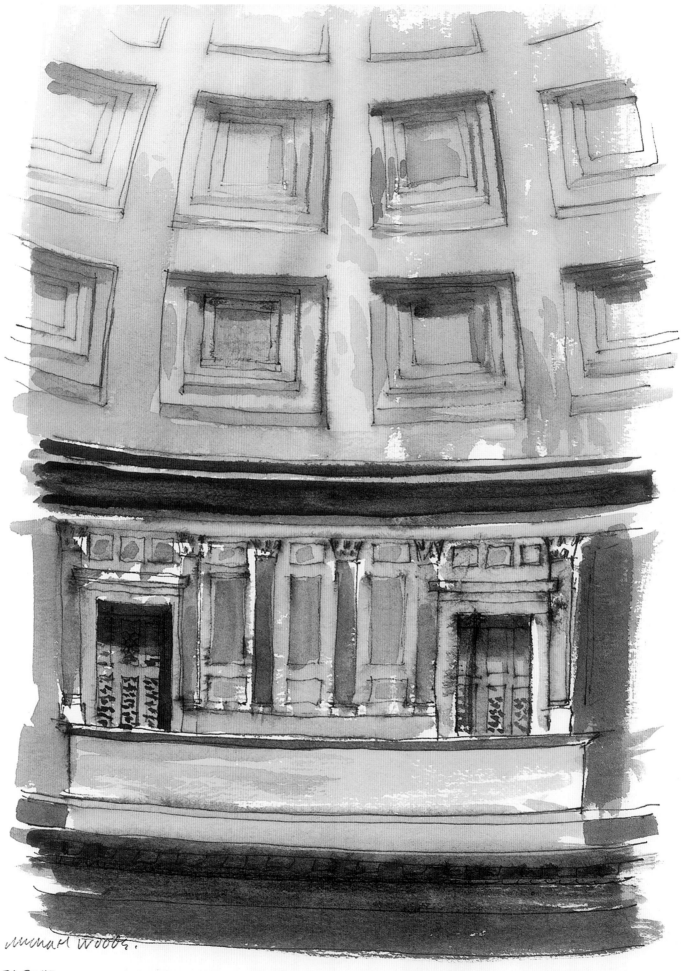

michael woods.

31.3.88.

THE PANTHEON, ROME, ITALY, 1988
• 33 x 23cm/13 x 9in • BLACK WATER-SOLUBLE INK, WATERCOLOUR ON WHATMAN 300g/m²/140lb PAPER • 40 MINUTES

COFFERING OF THE PANTHEON, 2000
• 25 x 18cm/10 x 7in • 2B PENCIL ON DAVID COX BROWN CARD • 20 MINUTES

DETAIL OF VAULT COFFERING, 2000
• 13 x 15cm/5 x 6in • BLACK WATER-RESISTANT INK CONTINUED BY 2B PENCIL WHEN FAULT DEVELOPED IN PEN ON BOCKINGFORD 425g/m²/200lb PAPER • 5 MINUTES

PANTHEON COFFERING, 2000
• 48 x 38cm/19 x 15in • WATERCOLOUR AND WAX STICK ON BOCKINGFORD 425g/m²/200lb PAPER • 3–4 HOURS

If I had to select one building in Rome, it would be the Pantheon, which dates from AD120–124. I am very moved when I pass through the original bronze doors. The circular space inside is thrilling and covered by a coffered concrete dome with the only light entering through an unglazed circular opening in its crown.

In 1988 I did a watercolour of part of the wall and dome. On my visit in 2000 I made a study of the coffering with another little drawing and some notes. Later I used these pieces of information to paint a series of watercolours of the dome.

I noticed that the shapes and character of the concrete coffering were quite complex. The light coming through the hole and hitting the surface was the lightest big tonal area. But higher up and to one side in my view, the light was partly reflected and therefore slightly darker. The shadows in the coffering were the darkest areas but the edges within them varied quite significantly. The upper ones took reflected

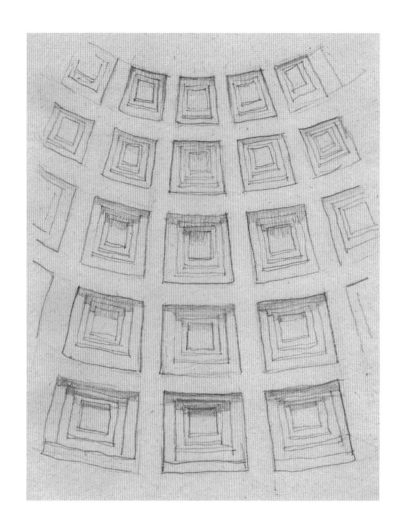

Opposite: The Pantheon. Above and left: Pantheon studies.

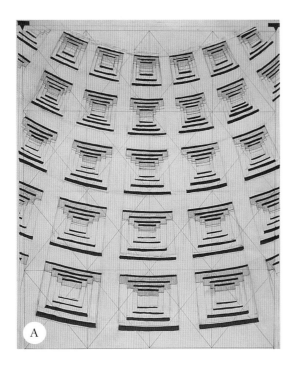

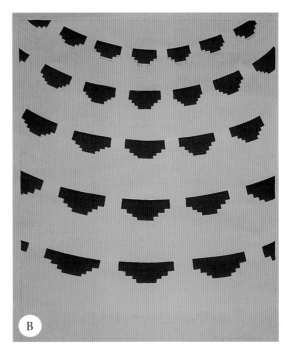

light from the floor of the Pantheon, while those at the bottom were facing upwards and received the most light from the hole.

I would not know until I had completed a painting if the inter-relationship of areas and their tones and colours would be right. I decided to be prepared to make perhaps half a dozen paintings where I could modify my decisions and consider how they came up to my broad outline.

In order to get and keep the structure reasonably correct, I prepared a sheet of thin card the full size of my intended painting. This used the diagonal grid method. On this I was able to place and draw each of the coffer hollows. They are not mathematically correct, for the last thing I wanted was to end up with a stiff, 'dead' pattern. I had to do a lot of adjusting with constant reference to the studies. For instance, I hadn't fully taken in the fact that the smallest top row have only three steps in the hollow while all the rest have four.

I decided that to keep the actual watercolour

application as free and direct as possible I would use my wax sticks to preserve the small ledges at the right tonal point, so by cutting slots through the card this would enable me to mark their position and of course they would define the placing of the whole slightly curved rectangle (Fig. A).

I then considered the shadows within each rectangle and decided that a second sheet of card, with those areas cut out, would enable me to mark their place relatively quickly, but also with enough precision to be convincing (Fig. B).

I then started the series. With an HB pencil I made very faint lines for all the structural edges I needed to know, by using the first card. The first watercolour wash went right across the whole paper and would become the lightest upward facing edges of the coffering (Fig. C). When this was dry I then applied clear wax to those edges. Then, with darker washes, I developed the main surfaces, which were lighter bottom right and darker top left. I kept the

C

D

E

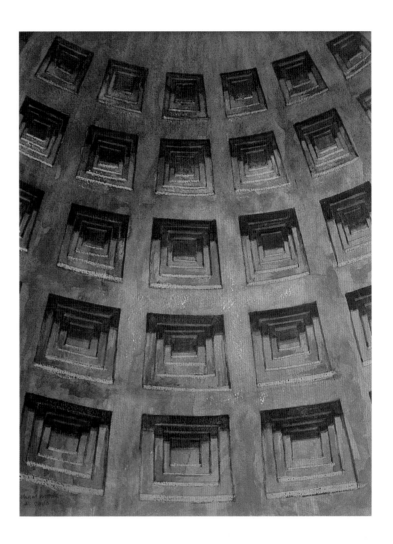

application varied – broken and with several subtle variations of colour (Fig. D). With the second card sheet I then very faintly marked the

shadow boundaries. These were important as they describe the depth of the hollows. The upper edges getting reflected light, which I had not waxed, had to be kept clear of the darkest shadow (Fig. E). Finally I went round the whole painting, modifying some colours and tones here and there, until I was satisfied that the whole concrete surface worked as one.

In all I made five versions and all are subtly different in their colours and tonal ranges, which describe the sheer weight of the structure and the light running across the surface of it.

Left: Painting stages C, D and E.
Above: Final painting.

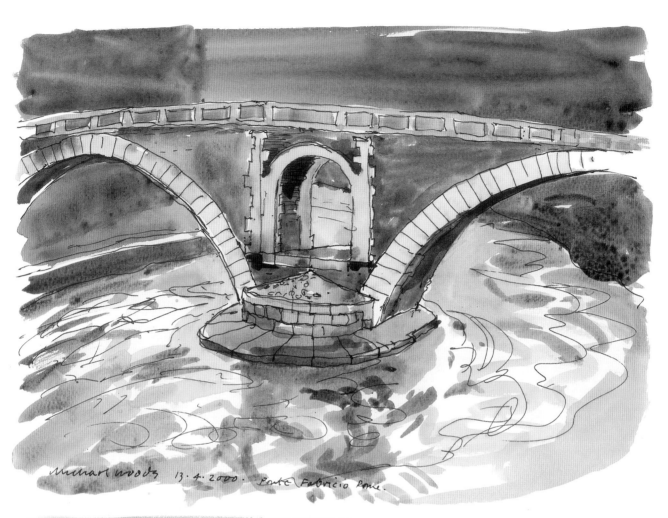

Michael Woods 13.4.2000 · Ponte Fabricio Rome.

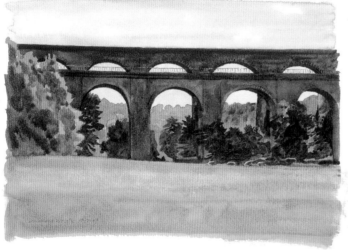

Bridges and Arches

THE PONS FABRICIUS, ROME, ITALY, 2000

• 25 x 33cm/10 x 13in • BLACK WATER-RESISTANT INK, WATERCOLOUR ON FABRIANO MURILLO 280g/m²/130lb PAPER • 20 MINUTES

Walking in Rome at the end of a good but long day, I managed to see this fabulous bridge, which dates from 62–21 BC. I felt that the quality of the structure deserved much more time and

consideration, but I had to get something down in about 20 minutes. Even the water was flowing in complicated eddies. I drew by reaction, measuring nothing and hoping that, more or less, the drawing would fit together.

Doing a little research later, I learned that the central opening is a flood water aperture. If I had the chance, I would certainly return to the site to draw it again.

Chirk Viaduct and Aqueduct, England, 1999

• 23 x 33cm/9 x 13in • Watercolour on Bockingford 425g/m²/200lb paper • 1 hour

I have always liked John Sell Cotman's painting of Chirk Aqueduct and so when I was in the area I took the chance to have a look.

The aqueduct was completed in 1801 and Cotman's painting is dated between 1806–7. In 1848 a railway viaduct was built alongside so I was rather saddened that Telford's beautiful simple arches were no longer seen alone as Cotman had seen them. Still I did a study of the two against the light.

Later I returned to show my wife the area and we walked under the two huge structures and into the fields beyond them – returning, I saw them in the sunlight rather than against it, and here is a good example of how the time of day – meaning in fact the position of the sun – can have a tremendous effect on the pictorial qualities.

The Capitol, Rome, Italy, 1988

• 36 x 25cm/14 x 10in • Black water-soluble ink, watercolour on Whatman 300g/m²/140lb paper in ring bound sketchbook • 1 hour

This bridge links two buildings of the Capitol. I recall the occasion because for part of the time I was surrounded by a large group of young Italian

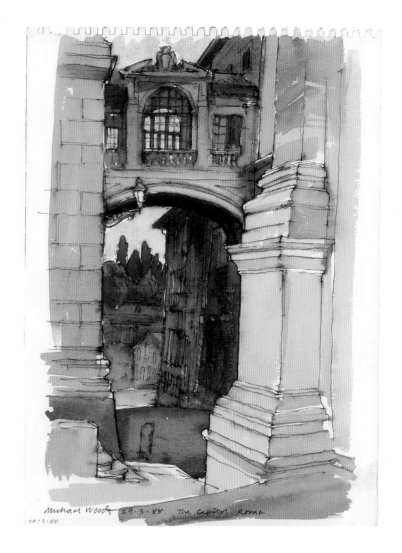

students. They were in a happy but boisterous mood and I found myself having to run a conversation with one who spoke English, who translated for the rest, while I continued painting with what remained of my concentration. But I am lucky because I am used to students, and having a brief comment with passers-by can be very pleasant. However, on some occasions I just apologise for not talking, particularly in the middle of using watercolour when I simply cannot stop – most people understand!

Opposite top: The Pons Fabricius. Opposite below: Chirk Viaduct and Aqueduct. Above: The Capitol.

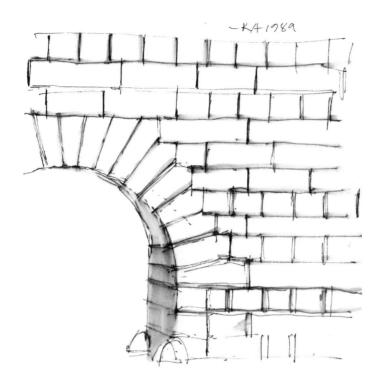

FORUM OF AUGUSTUS, FROM PHOTOGRAPH, 1989
- 20 x 15cm/8 x 6in • BLACK WATER-SOLUBLE INK ON CARTRIDGE PAPER IN BOUND SKETCHBOOK
- 10 MINUTES

This subject interested me in an exhibition at the Royal Academy in London. It was a photograph taken in 1854 and shows how the voussoirs relate to the courses of stonework. It gives me information to which I might refer at some time in the future, and this sort of drawing just gets filed away.

CLIFTON SUSPENSION BRIDGE, BRISTOL, ENGLAND, 1999
- 23 x 28cm/9 x 11in • BLACK WATER-SOLUBLE INK ON ARCHES AQUARELLE HP 300g/m²/140lb PAPER
- 30 MINUTES

Above: Forum of Augustus, Rome. Right: Clifton Suspension Bridge, Bristol, England.

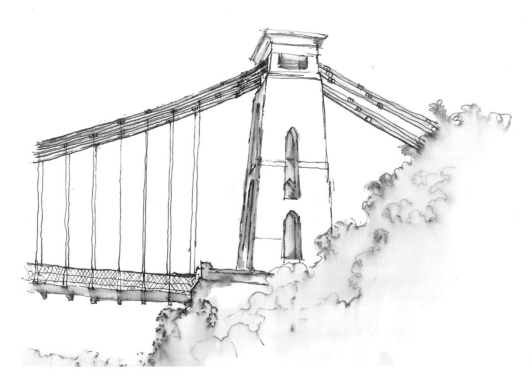

Having climbed up a steep path at the side of the Avon Gorge and finding an empty bench, this view was too golden an opportunity to miss. Generally I stand to draw and paint, particularly when working quickly, and in many situations it is not practical to sit as it usually changes the view. In this case it was ideal.

Here the suspension intervals are quite simple but still require care because when two separate sides are involved some gaps can become quite subtle. The other vexed question in a large object like this is where do you stop drawing? In a mount or a frame a composition can look considerably more decided but at the moment of drawing, a chopped off bridge can look very uncomfortable.

*Albert Bridge,
London*

ALBERT BRIDGE, LONDON, ENGLAND, C.1972

● 18 x 23cm/7 x 9in ● 8B PENCIL ON SMOOTH CARTRIDGE PAPER IN BOUND SKETCHBOOK ● 30 MINUTES

Quite a lot of bridges depend on various suspension systems. I had a commission for a

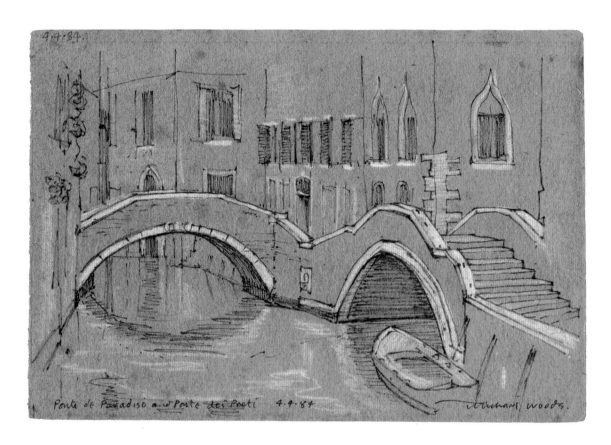

Ponte de Paradiso and Ponte dei Preti 4.4.84 Michael Woods.

painting of this particular bridge and I needed some confirmation of one or two shapes. The spaces involved with a structure like this can be a problem; the cables sag between two points, and cables on other parts do the same thing, which from my diagonal view made the sets of cables cross. These lines form areas of sky, which create the particular pattern that characterizes this bridge, so they needed to be reasonably accurate.

PONTE DEL PARADISO AND PONTE DEI PRETI, VENICE, ITALY, 1984
• 18 x 25cm/7 x 10in • BLACK WATER-RESISTANT INK, WHITE PENCIL ON BROWN PAPER • 30 MINUTES

Venice is a magical place and unfolds itself with twists and turns, bridges and reflections. On a visit in 1984 I was using a very old sketchbook with a tan brown paper. The paper was a bit too absorbent for ink, but it gave a good mid-tone, so nonetheless I persevered with black pen and white pencil to good effect.

These two charming bridges just had to be drawn. The white stonework was very useful for it introduced some light elements in a grey day with no strong shadows.

TOWARDS THE GRAND CANAL, VENICE, ITALY, 1984
• 23 x 15cm/9 x 6in • BLACK WATER-RESISTANT INK, 3B PENCIL, WHITE AND RED PENCIL ON BROWN PAPER • 15 MINUTES

I liked this view because of the way the architecture produced the effect of five or six layers reaching across the Grand Canal.

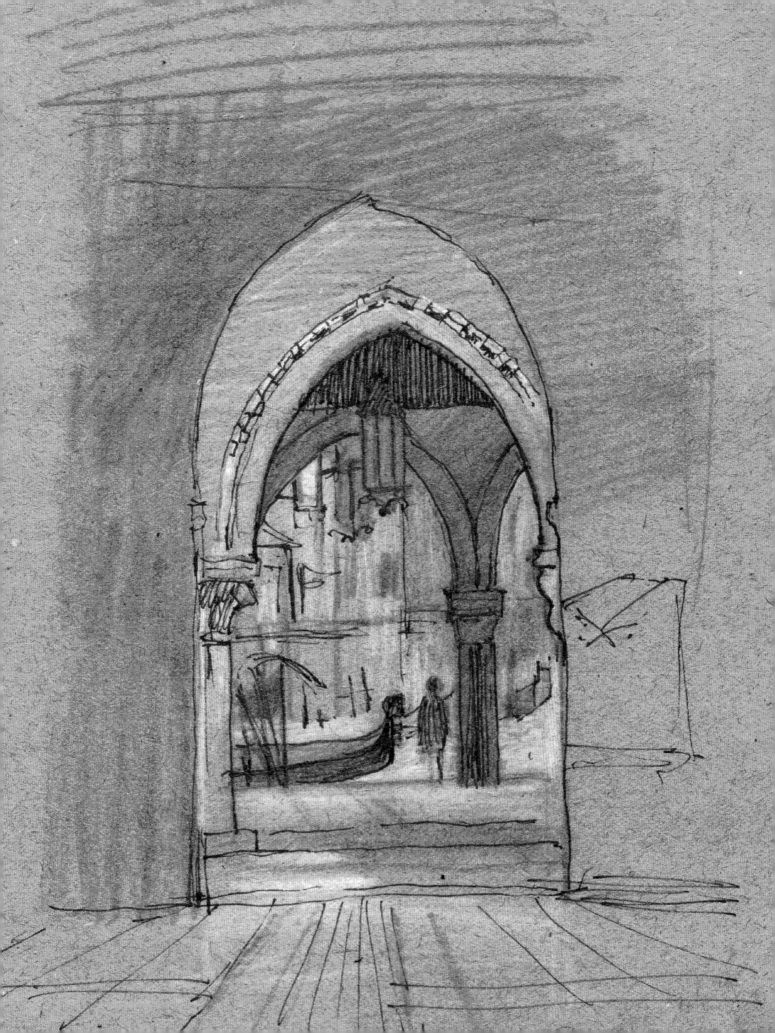

Tantalizing Trees

While in Singapore, I visited the Botanical Gardens where I hoped to find plants and trees totally unknown to me. I was not disappointed – many of the trees were quite fantastic and very drawable.

DOUBLE COCONUT, 2000
• 25 x 36cm/10 x 14in • 4B PENCIL ON BOCKINGFORD 425g/m²/200lb PAPER • 20 MINUTES

TRACING PAPER DEVELOPMENT, 2000
• 24 x 30cm/9¹/₂ x 12in • BLACK AND WHITE POSTER PAINT ON TRACING PAPER

Above: Double coconut.
Right: Tracing paper development.

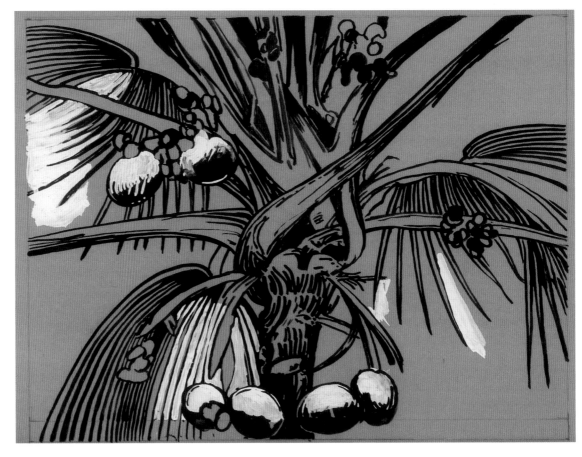

DOUBLE COCONUT PRINT, 2000
• 24 x 30cm/9¹/₂ x 12in • BLACK PRINTING INK
ON CARTRIDGE PAPER

I stood quite close to the Double Coconut and looked up into the main central structure of branches. I wanted to record the vigorous, quite powerful shapes, and decided that a 4B pencil would allow me to make shapes and lines freely but with some sensitivity in tone as, lightly applied, the lines could be pale, while heavy pressure would produce dark ones. As almost all the lines were swinging curves, my hand had to move quickly to achieve them. I doubt if pen would have worked as well, because in a hot climate ink can dry quickly. So, pencil it was. It is often worthwhile having two pencils of the same grade available, thus saving the need to sharpen mid drawing. If it is needed, then a pocket knife or a retractable craft knife is superior to a rotary sharpener, which never uncovers enough graphite to serve well.

Back in my studio I wanted to make a lino print from the pencil study as this would enable me to make the image more dramatic. The size was ideal as it was, so I made a tracing on which I could make the planned development in black paint. I also used some white paint to alter first thoughts. By this process any number of versions can be considered before selecting the one to be cut.

PALM TREE, LANZAROTE, 2001
• 23 x 15cm/9 x 6in • BLACK AND WHITE PENCILS
ON GREY 300g/m²/140lb CARD • 20 MINUTES

During my visit to Lanzarote, there was a warm but strong wind. It animated the trees wonderfully but when I came to draw this one, I had to watch for almost more time than I drew in order to sort out the positions of the branches and yet try to retain something of their vigour.

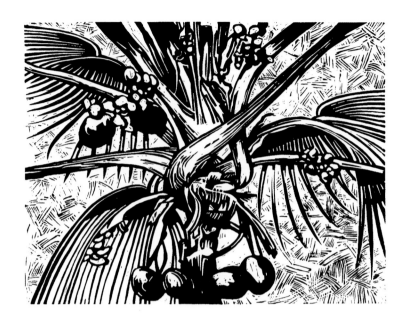

Above: Double coconut print.
Left: Palm tree.

SINGAPORE PALM PRINT, 2000
• 33 x 23cm/13 x 9in • GOLD INK ON RED
150g/m²/70lb PAPER

The Singapore Palm was painted directly with
watercolour. I stopped the first study because
I sensed that, as a strong breeze was moving
the whole tree, my placing of the branches
was drifting out of drawing. So, starting a
second time, I did a little plotting out with
some small marks of watercolour to establish
the angles and spaces. The lino print
development was made in the same way as
the Double Coconut, but printed in gold ink
on red paper.

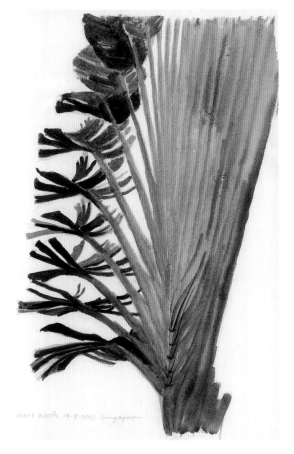

Above:
Singapore palm,
first study.
Right: Second
study.
Opposite: Palm
print.

SINGAPORE PALM, 2000
• 20 x 13cm/8 x 5in • WATERCOLOUR ON
BOCKINGFORD 425g/m²/200lb PAPER
• 15 MINUTES

SINGAPORE PALM, 2000
• 36 x 23cm/14 x 9in • WATERCOLOUR ON
BOCKINGFORD 425g/m²/200lb PAPER
• 1 HOUR

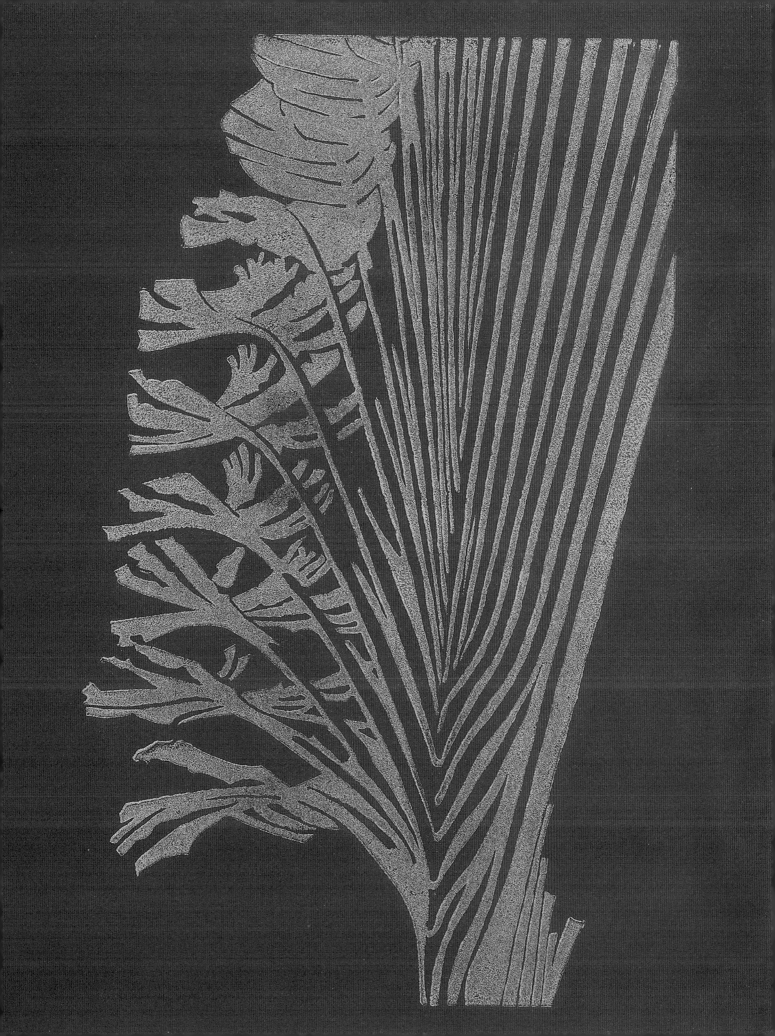

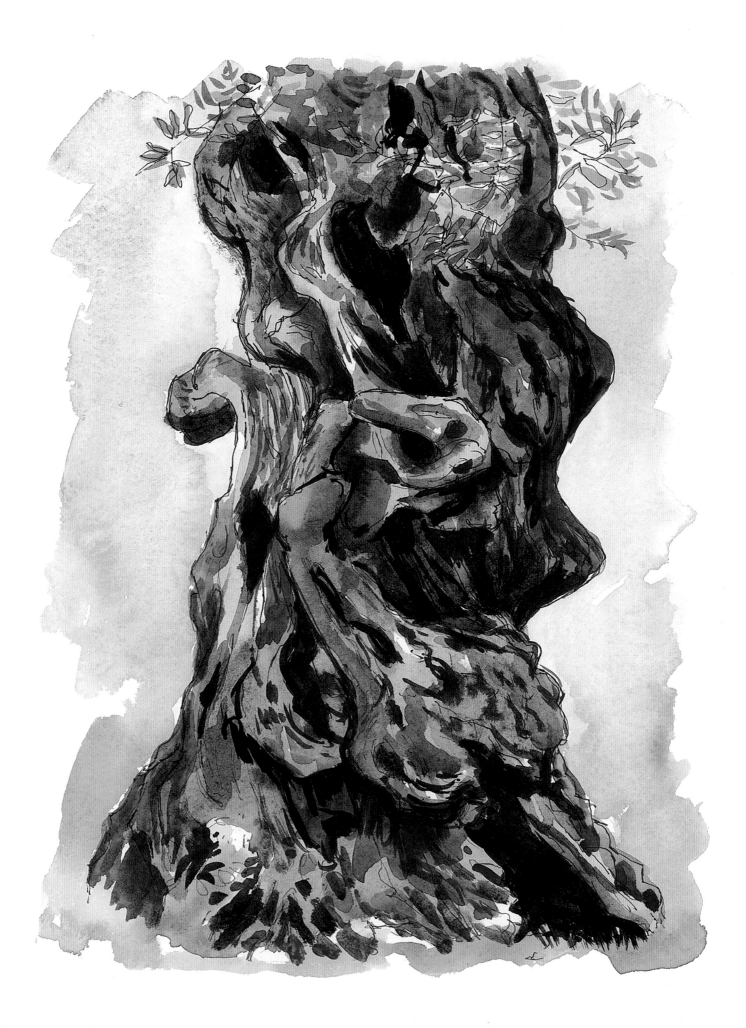

OLIVE TREE, CORFU, 1995

• 33 x 23cm/13 x 9in • BURNT UMBER WATER-RESISTANT INK, WATERCOLOUR ON HAND-MADE INDIAN PAPER • 30 MINUTES

This 500-year-old olive tree trunk was massive. It was growing at a juction point of tracks leading to a building that housed an active olive press. I was struck by the tree's twined form, in fact it could almost have been a carved pillar. I still have thoughts of developing the sketch into a major work.

SWEET CHESTNUT, PETWORTH PARK, ENGLAND, 1989

• 20 x 18cm/8 x 7in • BLACK WATER-SOLUBLE INK ON CARTRIDGE PAPER IN BOUND SKETCHBOOK • 15 MINUTES

This Sweet Chestnut had a huge, hollow interior. A strong but low winter light was falling on the tree and this needed emphasis. Ink with water or spit can quickly give areas of rich dark, which by contrast will model the whole trunk and show where the light is falling.

A SURREY WOOD, ENGLAND, C.1989

• 18 x 13cm/7 x 5in • BURNT UMBER, WATER-RESISTANT INK, WATERCOLOUR ON HAND-MADE INDIAN PAPER • 15 MINUTES

This was a rather open-floored wood and many trees could be seen clearly. This particular specimen had a marvellous swinging root. The paper in my little sketchbook was rather bumpy and absorbent but my pen flowed wetly and moved well enough. The colour changes of the tree were also impressive, but I now think that I may have somewhat overstated them. Rather than trying to change a sketch, I prefer to make a second one, only on this occasion my grand-daughter had decided it was time to go home.

Opposite: Olive tree.

Left: Sweet Chestnut.

Below: A Surrey wood.

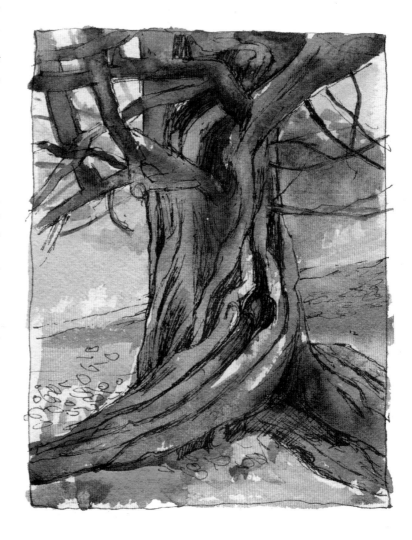

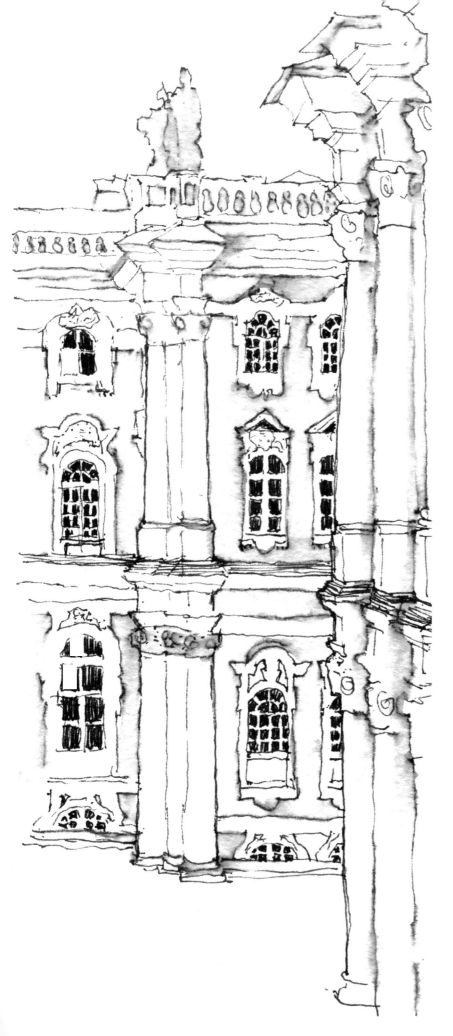

Through Windows

I like visiting buildings and special ones can hold such a wealth of decoration, furniture and paintings that it can take a lot of concentration to look and digest even some of it. But, however good, I am always tempted to look outside from upper windows. Gardens, courtyards and other parts of the building sometimes seem quiet and remote and possibly unchanged for many years, and those views often feel closer to the people who used to live there.

THE WINTER PALACE, ST PETERSBURG, RUSSIA, 1999
• 25 x 13cm/10 x 5in • BLACK WATER-SOLUBLE INK ON BOCKINGFORD $425g/m^2/200lb$ PAPER • 30 MINUTES

From the Winter Palace the views over the River Neva and to other parts of the city are beautiful. I particularly liked the views to a wing on the south side and found a convenient window that placed me out of the way of fellow visitors. I asked for permission to draw and received a nod and a smile. As I drew I realized that of the 12 windows in my view there were 6 designs. I wondered if this meant that not all of the designs were by the same architect, or was this variety caused by Catherine the Great's desire to replace the rococo with a more classical style?

MUSÉE D'ORSAY, PARIS, FRANCE, 2000
• 13 x 15cm/5 x 6in • 2B PENCIL ON CARTRIDGE $150g/m^2/70lb$ PAPER • 10 MINUTES

MUSÉE D'ORSAY, PARIS, FRANCE, 2000
• 18 x 18cm/7 x 7in • BLACK AND WHITE PENCIL
ON GREY 150g/m²/70lb PAPER • 10 MINUTES

For years I had been told by my doctor, a painting enthusiast, that I should visit the Orsay Museum, and when I finally did I found it most impressive. The change of use of a building (it had been a railway station) can bring surprises and add to its character. Seeking lunch and going to the top floor, I found that I was looking at a huge clock face, but from inside; it felt strange that the hands were moving backwards! But it was the view beyond that ultimately caught my attention. The November sun had come out from behind clouds and was illuminating Sacre Coeur and the hill of Montmartre. I found a convenient side window and drew.

The distance was really too great and I found it quite difficult to interpret the shapes because I was unfamiliar with the layout of the building. That may sound strange, but I find that it is possible to draw or paint something by just reacting to the shapes and colours or tones, and the result is recognizable although I might have missed some important characteristics. If I know a building quite well, then even though it may be hazy or indistinct, I can interpret the subtle qualities with more sensitivity.

A short time later walking through another gallery I made a second drawing using white and black pencils on mid grey paper. Sacre Coeur is built of white stone so drawing with a white pencil made it a positive shape, whereas using a lead pencil the first time it became a rather negative space defined by a line.

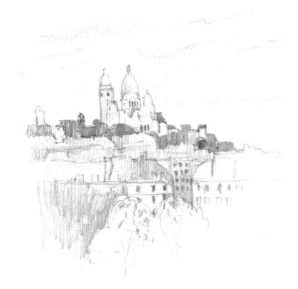

Opposite:
Winter Palace,
St Petersburg.
Left and below:
Montmartre
from the Musée
d'Orsay, Paris.

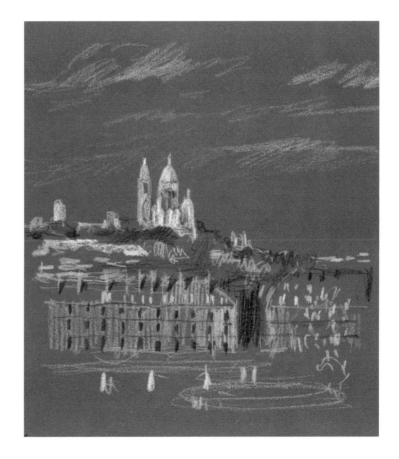

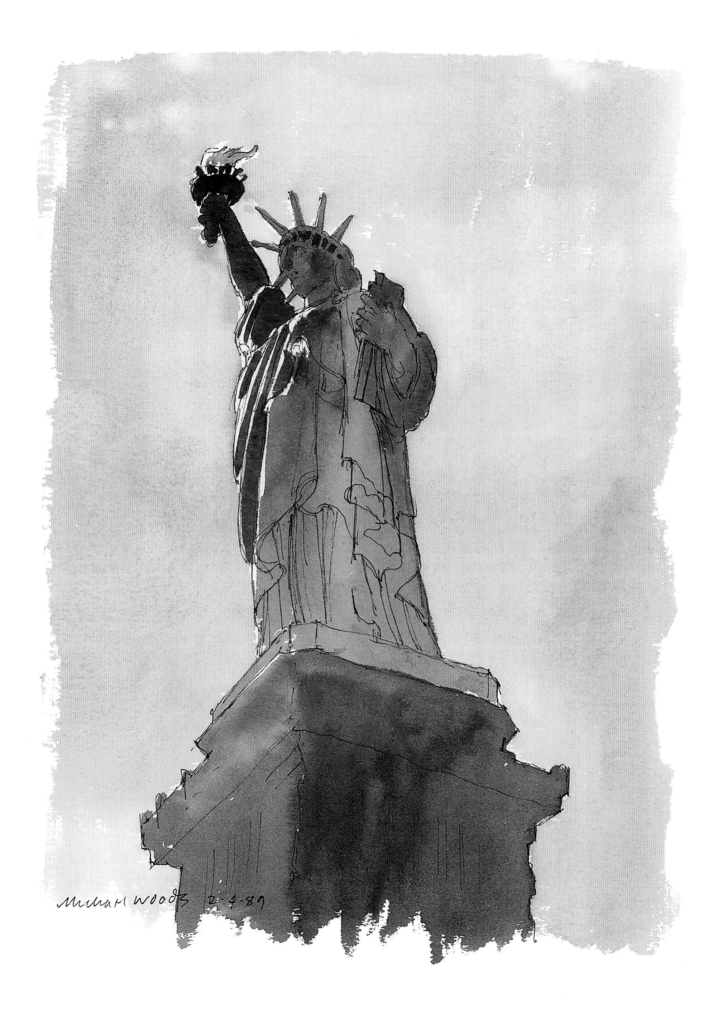

Michael Woods 2-7-89

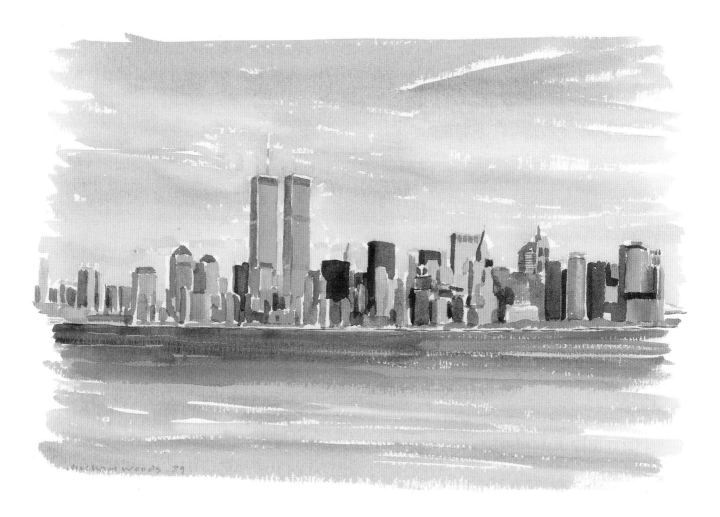

New York & Washington

STATUE OF LIBERTY, NEW YORK, USA, 1989

- 33 x 23cm/13 x 9in • BLACK WATER-RESISTANT INK, WATERCOLOUR ON WHATMAN 300g/m²/140lb PAPER • 30 MINUTES

While visiting relatives, we were taken to Liberty Island on which the Statue stands. I deserted the rest of the family and took on the neck-bending task of drawing this huge figure rising above me. I found it very exciting and the fact that I was drawing almost against the light was beneficial, because most of the tonal values were dark and I could treat them quite simply. The reflected light down the body was achieved in part by lifting off wet watercolour with a dryish brush.

MANHATTAN SKYLINE, NEW YORK, USA, 1989

- 25 x 36cm/10 x 14in • HB PENCIL, WATERCOLOUR ON WHATMAN 300g/m²/140lb PAPER • 1 HOUR

I was thrilled with this view but assessed that such an intricate set of shapes and such

Opposite: Statue of Liberty. Above: Manhattan skyline in 1989.

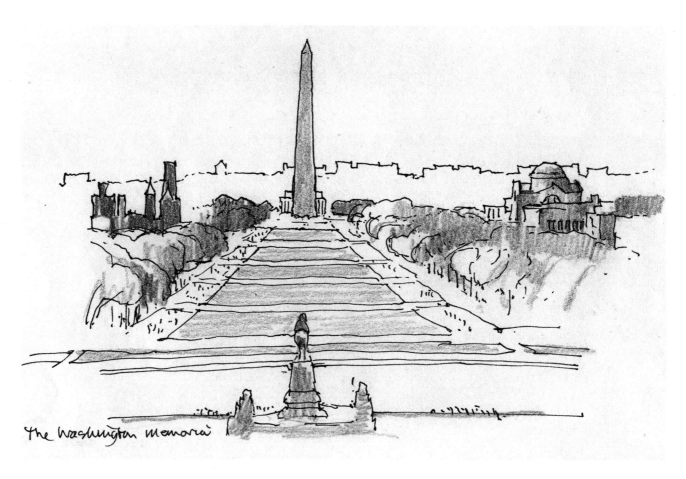

The Washington Memorial

Washington Monument

beautiful quiet colours would mean a major undertaking. I used an HB pencil to place the main shapes. It then took quite a long time to build up little blocks of colour while trying to keep the whole collection in one mass.

This colour sketch and a line drawing of the same subject supplied me with the information for several oil paintings in the following months.

WASHINGTON MONUMENT, WASHINGTON, DC, USA, 1989

• 15 x 23cm/6 x 9in • BLACK WATER-RESISTANT INK, 3B PENCIL ON THIN CARTRIDGE PAPER IN BOUND SKETCHBOOK • 15 MINUTES

Having walked down this great Mall to the Capitol, I wanted to make a drawing of the view looking back from this elevated position. The size and scale of a big place is hard to grasp and I remember thinking before I started that I was going to be drawing more air than anything else. The perspective lines towards the Washington Monument, with the Lincoln Memorial $^3/_4$ mile beyond, are critical elements that help to describe the distance – some $2^1/_4$ miles in all.

Fleeting Moments

ECLIPSE OF MOON, 9 JANUARY 2001

• 15 x 15cm/6 x 6in • 3B PENCIL ON CARTRIDGE 150g/m²/72lb PAPER • 3 MINUTES

ECLIPSE OF MOON PAINTING, JANUARY 2001

• 48 x 38cm/19 x 15in • WATERCOLOUR ON BOCKINGFORD 425g/m²/200lb PAPER • 2 HOURS

It was touch and go whether an eclipse would be visible from my house and one or two checks outside soon showed that a thick blanket of cloud covered the area, so I rather gave up since there was nothing I could do about it.

A while later I did a final, final check, and there it was. The sky had cleared and the moon was almost covered. Dashing for a sketchbook and grabbing a pencil I rushed outside and made two very odd drawings of what seemed to be a very small moon. By the time the second drawing – this one – was complete, the moon was covered.

A week or so later I decided to try using the two sketches in a more controlled way. I made a paper circle the size I considered right for the overall paper rectangle I had planned. This I used to make a faint circular line I could work to. The edge wasn't that critical because, when I had finished dealing with the moon, I intended to paint the sky a very dark blue–black with designers gouache, which would enable me to outpaint any flaws in the boundary, while keeping the actual edge slightly diffused.

Left and below: Eclipse of the Moon, drawing and painting

Corinthian
510 BC.
Apulia.

Museums and Exhibitions

Visiting exhibitions, museums and collections has always been part of my life. We are so lucky that we are able to have such superb chances to look and think. Because they hold such incredibly diverse objects, it makes me selective and can present surprises in all sorts of areas that I might not previously have considered.

Helmets – a selection

I have always liked helmets. There is a Roman one in Norwich Castle Museum, which was found when a local river was being dredged. I've often wondered what happened to the soldier who reported it lost!

I have drawn many helmets – in fact looking through my sketchbooks I have found 30 so far. Most have a sort of face character just by themselves, and the dark space inside is quite evocative.

Who wore them? The shape may look quite simple but the proportions of the eye-holes and the nose piece are very important and the dome of the head, helped by the reflected light off the corroded surface, describes the whole volume.

CORINTHIAN (510 BC)
• 18 x 13cm/7 x 5in • BLACK WATER-SOLUBLE INK, WHITE PENCIL ON BROWN PAPER • 10 MINUTES

The craftsman who made this obviously took some pleasure in the 'eye-brows'. This is a particularly good example of how a face has been brought to the helmet's surface. The wearer has a new sort of skin and I found that this surface had to be drawn with sensitivity so that its qualities were not lost.

UNNAMED

- 14 x 9cm/5^1/$_2$ x 3^1/$_2$in and 14 x 11cm/5^1/$_2$ x 4^1/$_2$in • BLACK WATER-SOLUBLE INK ON THIN CARTRIDGE PAPER IN BOUND SKETCHBOOK • 5 MINUTES EACH

The reinforced edge gives a rather decorative quality to the first drawing; the side view shows the particularly lovely sweeping curve at the back of the neck.

BRONZE CORINTHIAN (500 BC)

- 13 x 8cm/5 x 3in • BLACK WATER-SOLUBLE INK ON CARTRIDGE PAPER IN BOUND SKETCHBOOK • 5 MINUTES

This helmet shows a degree of refinement in its form. I enjoy the challenge of seeing if, in 5 minutes, I can make my judgements digest the shapes that are in front of me and put them down so that the important qualities are described.

UNNAMED

- 15 x 13cm/6 x 5in • BLACK WATER-SOLUBLE INK, 2B PENCIL ON THIN CARTRIDGE PAPER IN BOUND SKETCHBOOK • 10 MINUTES

This helmet has a sort of decorative face below the eye slot. The use of a pen for the main structural lines and pencil for the tonal additions work well together. The fact that the tone does not obliterate the lines is particularly helpful when enlarging.

APULO-CORINTHIAN (400–350 BC)

- 13 x 10cm/5 x 4in • BLACK WATER-SOLUBLE INK, WHITE PENCIL ON BROWN PAPER • 10 MINUTES

All the helmets I have drawn were displayed in glass show cases and the lighting usually models the domed shapes rather effectively. Using a half

tone paper allows the darker marks made with ink to contrast with the white pencil. Together they can describe both form and texture.

CORINTHIAN (600 BC)

- 13 x 9cm/5 x 3^1/$_2$in • BLACK WATER-SOLUBLE INK, WHITE PENCIL ON BROWN PAPER • 5 MINUTES

The white pencil is valuable here in describing the smoothly domed top of the helmet. The relationship between pencil and paper is important. I've always found it worthwhile to try out several makes of both so that a final choice can be made. Then, when working, all attention can be given to the subject.

Opposite top:
Corinthian (510 BC).
Opposite below:
Unnamed.
Above clockwise:
Bronze Corinthian,
Unnamed, Corinthian,
Apulo-Corinthian.

THE NEREID MONUMENT, BRITISH MUSEUM, LONDON, ENGLAND, 1998

• 23 x 18cm/9 x 7in • BLACK WATER-SOLUBLE INK, WHITE PENCIL ON BROWN PAPER • 40 MINUTES

Grandly presented, this monument is well worn, but from a distance it was quite satisfying to get the overall proportions reasonably right. It dates from 390–380BC and was reconstructed between 1967 and 1969. Proportion in sketching is really one of the most important qualities to assess. The details or small parts, which have largely gone from this, are frequently less important than the overall shape. After all, if this were set up on a hill, from a distance you wouldn't realize that the figures had no heads.

CROSSBOW MECHANISM (C.40 BC)

• 13 x 8cm/5 x 3in • BLACK WATER-SOLUBLE INK ON FABRIANO 280g/m²/130lb PAPER • 3 MINUTES

I am not certain where I drew this – possibly at an exhibition of some of the Chinese Warriors. I usually complete the information of where and when, but for some reason I didn't in this instance. I liked the shape, just as it was, and the tone from wetting the ink is very helpful in showing the chunky nature of the mechanism.

PANTHEON CAPITAL, LONDON, ENGLAND, 1998

• 18 x 18cm/7 x 7in • BLACK WATER-SOLUBLE INK, WHITE PENCIL ON BROWN PAPER • 40 MINUTES

I had two meetings in London, with time between, so I paid a visit to the British Museum. I had no objective and simply walked and looked until I found something I wanted to draw. I thought this pilaster capital from the Pantheon was rather fine. It had been made between AD118 and AD128 and then removed from the building in 1747 when changes were made in the wall treatment.

Opposite: Nereid Monument. Left: Crossbow mechanism. Above: Pantheon Capital.

The brown mid-tone paper became a good middle point between the areas getting most light and the black ink used for the hollows and shadows.

SHEET OF CERAMICS DRAWINGS FROM THE WALLACE COLLECTION, LONDON, ENGLAND

• 30 x 25cm/12 x 10in • BLACK WATER-SOLUBLE INK ON WHATMAN 300g/m²/140lb PAPER • 5 MINUTES EACH

When looking at ceramics I generally tend to record one particular point. At the top of the sheet is my judgement of the cross section of a shallow dish. Below is a drawn line analysis of panels of decoration. The bottom shows another cross section with a guess at the recession of the turned foot. The fact that I am a potter means that I already know the procedures and processes involved in both throwing and decorating, so the drawings are not an academic copy but a sort of shorthand to remind me what the potter had done some 500 years before.

SHEET FROM THE VICTORIA & ALBERT MUSEUM, LONDON, ENGLAND

28 x 25cm/11 x 10in •BLACK WATER-RESISTANT INK, FINE AND COARSE PENS ON GREY SUGAR PAPER • 2–5 MINUTES EACH

Five pieces of decorative information, and all were samples of pigment decoration laid on to a glaze.

Opposite: Studies from The Wallace Collection, London.
Above: Studies from the Victoria & Albert Museum, London.

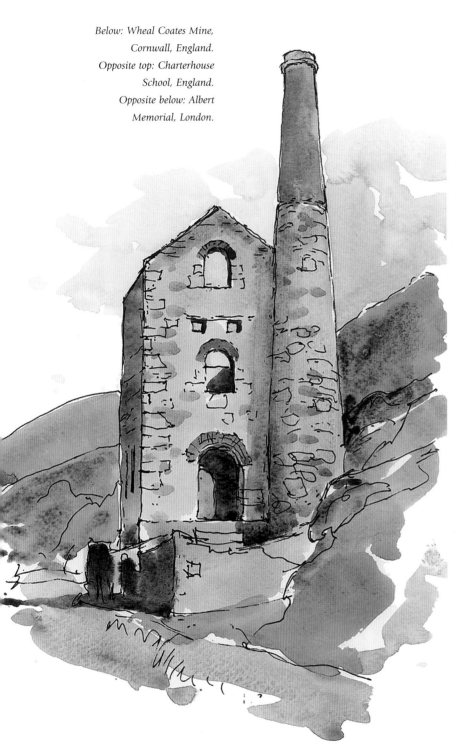

Below: Wheal Coates Mine,
Cornwall, England.
Opposite top: Charterhouse
School, England.
Opposite below: Albert
Memorial, London.

Surprises

WHEAL COATES MINE, NORTH CORNWALL, ENGLAND, 1998

• 28 x 20CM/11 x 8IN • BLACK WATER-RESISTANT INK, WATERCOLOUR ON FABRIANO 280g/m²/130lb PAPER • 20 MINUTES

The intention for the day was a coast path walk with wonderful cliffs and pounding seas, but it was not long before I had stopped at Wheal Coates mine – or what used to be. It is a handsome structure, and possibly the quick enthusiastic handling makes it look more cheerful than a more precise drawing might have conveyed. I remember feeling that the Fabriano paper was not really absorbent enough to work quickly, and everything seemed to be wet at the same time: it is curious how subtle the variations can be when subjects and working speeds vary.

CHARTERHOUSE, GODALMING, SURREY, C.1990

• 15 x 15cm/6 x 6in • WATERCOLOUR ON WHATMAN 300g/m²/140lb PAPER • 10 MINUTES

I had been teaching a group of pupils in the school grounds about the structure of trees and, returning at the end of the class, I noticed the statue of the founder, Thomas Sutton, on his plinth in the light against the shadows beyond. The school buildings changed enormously during the day as the sun moved round. I grabbed the chance to record this particular moment...and it was made possible because I had my drawing bag with me!

Even when you know a place well and have seen it over many years, there will still be times when because of the season, the time of day, or the weather conditions, special things come together and you will be in the right place at the right time. Sadly, I've also known a lot of the

opposite – a potentially good place that has no visual excitement because I'm there at the wrong time. However, this sometimes comes about because I have anticipated what I thought a place should be like and when I am actually there, the reality is different. Some sites may be fascinating to walk round, but they do not necessarily make pictorial compositions. Whatever the subject, it has to present a set of shapes that react and relate with one another and the rectangle.

But one of the advantages of having a range of materials with which to work is that by taking a different approach, fresh thoughts can develop. With buildings for example, the colour may be very undramatic on occasion but the structure might still be drawn most forcefully with black ink and monochrome washes. Similarly, disappointment with, say, the interior of a big house may suddenly spark enthusiasm with some small detail, such as window shutters and door hinges.

THE ALBERT MEMORIAL, KENSINGTON GARDENS, LONDON, ENGLAND, 1982
• 18 x 13cm/7 x 5in • WATERCOLOUR ON WHATMAN 300g/m²/140lb PAPER • 10 MINUTES

I had just left an exhibition when the Albert Memorial caught my attention. I wasn't thinking about architecture, but the rather rich colours and the fact that it was standing sufficiently far away for the sculptural detail to be lost into the whole shape, made me want to react. The paper wasn't large enough to get the whole Memorial in, and had I worked smaller, it would have made the drawing impossibly fiddly. I find that when sketching quickly I cannot draw too small – somehow my hand needs enough space to move. Though this little study holds together quite well, it lacks the amount of information a more developed work would require. So another study would be needed if this were to be taken further.

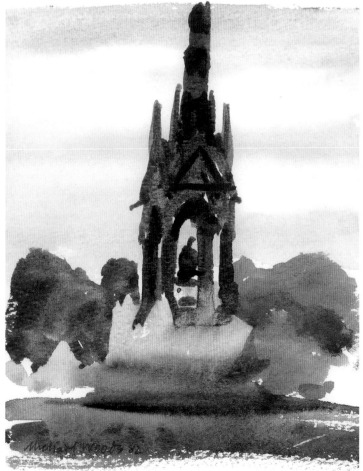

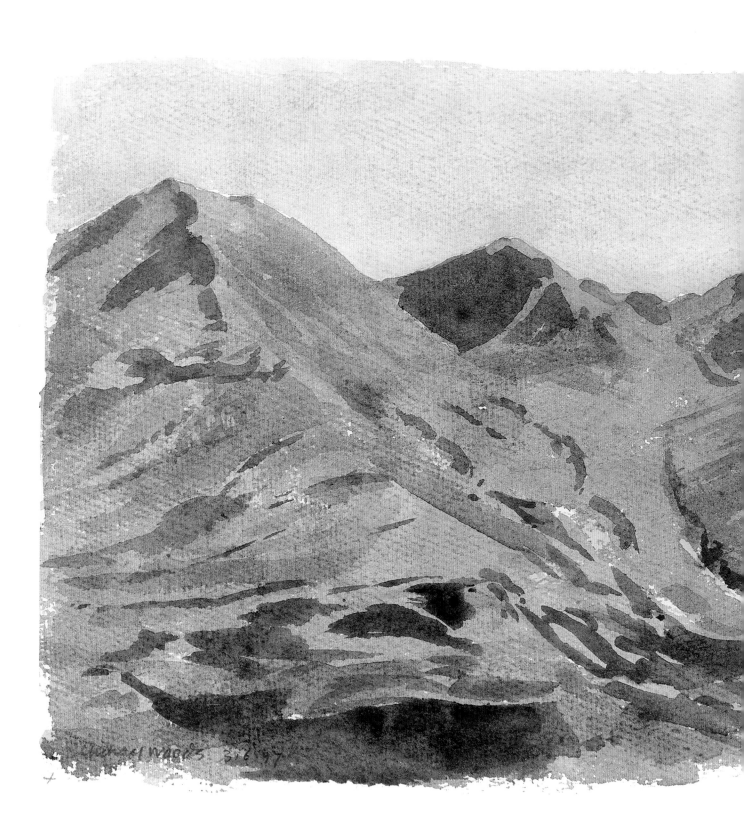

THE BEN EIGHE RANGE, SCOTLAND, 1997

- 25 x 36cm/10 x 14in • WATERCOLOUR ON HAND-MADE INDIAN PAPER • 20 MINUTES

I had not walked and clambered up a mountain before, but suitably booted, we set off on a National Nature Reserve Mountain Trail. Even in much less hazardous conditions I have found that good footwear considerably helps access to drawing places – even rocky beaches can be quite difficult.

As we were going up 550m/1,800ft, before setting off I emptied out as much as I could from my drawing bag – and also selected a light, plastic watercolour box. Much of the way it was essential to have both hands free and, though the route was marked with cairns, some rocks were quite large to clamber over, so a good well-made drawing bag, which can be carried on the back, was important.

When we reached the plateau the whole scene was a total surprise. Having started out in woodland, the grey rock slopes of the four peaks ahead were quite thrilling. We took a rest and I painted. I realized that the shadows played a vital part in the description of the mountains. As I worked they moved, and had I been able to select the time of day their whole appearance would have been quite different – and perhaps more remarkable – but of course I had no choice as we still had a 2-hour walk down. I am glad that I took my 25 x 36cm/10 x 14in sketchbook, for at least I had enough space to deal with these vast shapes.

Ben Eighe range, Scotland

Michael Woods 10·9·2000

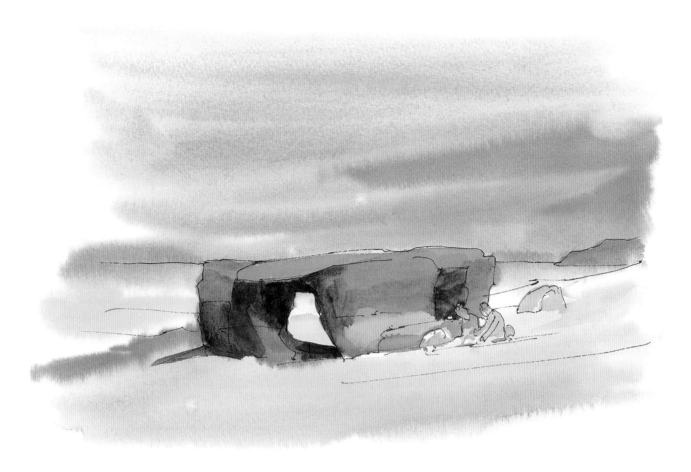

FISHING HUTS AT HASTINGS, ENGLAND, 2000

• 33 x 25cm/13 x 10in • BLACK WATER-RESISTANT INK, WATERCOLOUR ON BOCKINGFORD 425g/m²/ 200lb PAPER • 1 HOUR

I know these fishermen's huts at Hastings quite well and they have been the subject of several drawings and paintings. I was walking a slightly different route through the area in which they stand when my eye was caught by this part of the group. I have often found that objects or places I know can suddenly look quite different when they are seen from another angle. I stopped!

This study might be considered right on the edge of the division between a sketch and a finished work. This is possibly because the lines of the weather-boarding look tight and accurate. Well they are reasonably, but they draw quickly and because across the group there are few colour variations they also paint quickly.

REMAINS OF AN ARMY LOOKOUT POST, WEYBOURNE, NORFOLK, ENGLAND, 1990

• 20 x 28cm/8 x 11in • BLACK WATER-RESISTANT INK, WATERCOLOUR ON WHATMAN 300g/m²/140lb PAPER IN SPIRAL BOUND BOOK • 20 MINUTES

I was walking on the beach with a friend, having a pleasant afternoon showing him

Opposite: Fishing huts at Hastings. Above: Remains of an army lookout post.

Above: Tent.
Opposite:
Charterhouse
School.

several places on the north Norfolk coast. The tide was low and this old concrete wartime bunker was very noticeable – particularly because of the bright green seaweed on it. Our visit was therefore slightly extended because I wanted to record it. Some 10 years later I think it has finally been swallowed up by the sea.

TENT, C.1968
• 23 x 36cm/9 x 14in • BLACK WATER-SOLUBLE INK, 2B PENCIL ON SMOOTH PRINTING PAPER IN BOUND BOOK • 20 MINUTES

I've always liked the atmosphere in large tents, and many years ago I had to visit a Summer Show site when I was involved with a particular display. The tent had been erected but was totally empty and looked most attractive with the sun glowing through the many slight variations in the creamy buff strips of canvas of

which the whole long tent was made. My colour notes added further information which, even 40 years on, mean that I could now re-work this design.

CHARTERHOUSE, NEW BLOCK, GODALMING, SURREY
• 23 x 13cm/9 x 5in • PENCIL, WATERCOLOUR ON WHATMAN 300g/m²/140lb PAPER IN SPIRAL BOUND BOOK • 15 MINUTES

I was teaching a pupil and thought it would make my points clearer if I did a demonstration sketch. The nearby building, which we could see out of the window, served the purpose well. But for me the study goes further than making some technical points about painting, for I had looked at this corner for more than 30 years and the comings and goings of my schoolmaster life passed that way as well.

*Opposite top:
Pin Mill,
Suffolk,
England.
Opposite below:
Fishing fleet.
Left: Drawing
composition.*

Looking at Boats

PIN MILL, SUFFOLK, ENGLAND, 1993

- 18 x 25cm/7 x 10in • BURNT UMBER WATER-RESISTANT INK ON HAND-MADE INDIAN PAPER
- 20 MINUTES

Boats at moorings, tides moving up and down, people bending into small spaces or tugging at things – I find boats almost anywhere and of any type or size are worth drawing when the opportunity arises.

Here in Suffolk a Thames Sailing Barge lies close to another similar hull that could well be being refitted. Even looking at the drawing makes me want to return to find further subjects.

THE FISHING FLEET, HASTINGS, ENGLAND, 2001

- 23 x 36cm/9 x 14in • BLACK WATER-RESISTANT INK ON BOCKINGFORD 425g/m²/200lb PAPER
- 1 HOUR

The Hastings boats motor into the beach and are then hauled up by a steel hawser while the crew place wooden beams under them. They are launched by being pushed back by caterpillar tractors.

The older boats are wooden clinker built, while new boats are welded steel. All are extremely drawable and their arrangement on the beach is always a marvellous complex assembly of shapes that can be emphasized by simply using black ink.

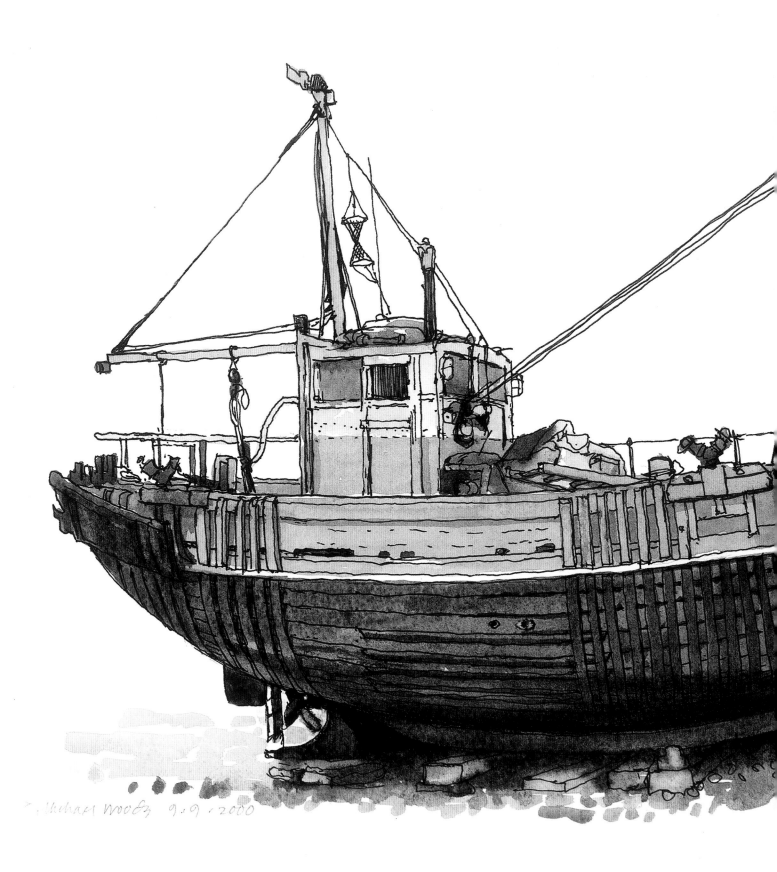

Michael Woods 9.9.2000

DRAWING COMPOSITION, 2000
- 10 x 15cm/4 x 6in • BLACK WATER-SOLUBLE INK ON BOCKINGFORD 425g/m²/200lb PAPER • 15 MINUTES

I made this sketch together with some notes because I had had some thoughts about a series of prints and I frequently make drawings to see if an idea is worth following up. Questions concerning composition can often then be clarified. The shapes of boats and equipment, such as masts, are difficult to visualize without a drawing.

FISHING BOAT RX73, HASTINGS, ENGLAND, 2000.
- 25 x 33cm/10 x 13in • BLACK WATER-RESISTANT INK, WATERCOLOUR ON BOCKINGFORD 425g/m²/200lb PAPER • 1½ HOURS

This is just about my favourite of the older boats and I found it well placed on a flat part of the beach. The drawing looks quite complete and a rather finished statement, but it was made to supply me with information.

Once the overall proportion of the hull is roughly worked out, it can be checked by counting the actual number of planks of which it is made. Another judgement might come from the vertical rubbing pieces, which can also be counted, and so the hull can be sub-divided into areas that in themselves have a proportion but that together with the other areas add up to the total shape. The size of a drawing can contribute much to the way in which it's drawn. In this case a 25 x 36cm/10 x 14in page enabled the parts to be big enough to draw in a simple strong way. In a small drawing the actual line size can almost remove the chance of small part description.

Anyway, once the main lines are drawn, and dots and marks placed to show where

Fishing boat RX73

Above: The
trading boat
Hathor
moored.
Right: Hathor
sailing.

other parts are located, the masts and ropes can be worked out with a few points and some angle judgements. It is then quite enjoyable to draw all the parts as an integrated whole. The colour was simple, with only two or three extra layers of wash to deepen tones.

HATHOR, NORFOLK BROADS, ENGLAND, 2001

• 13 x 23cm/5 x 9in • BLACK WATER-RESISTANT INK ON BOCKINGFORD 425g/m²/200lb PAPER • 20 MINUTES

HATHOR, NORFOLK BROADS, ENGLAND, 1998

• 13 x 23cm/5 x 9in • BLACK WATER-SOLUBLE INK ON BOCKINGFORD 425g/m²/200lb PAPER • 20 MINUTES

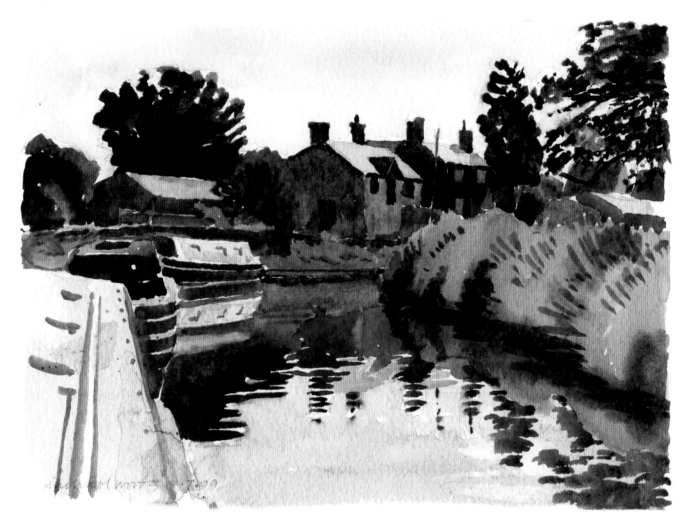

The Norfolk Wherry is a fine trading boat. One still sails, but there are others that were designed to carry people, and *Hathor* is one. The drawing on grey paper gave me the opportunity to use white pencil to draw the white sail as she moved quietly on the River Bure. The later drawing shows her moored for the night.

CANAL BOATS, LLANGOLLEN CANAL, WALES, 1999
• 18 x 23cm/7 x 9in • PENCIL, WATERCOLOUR ON BOCKINGFORD 425g/m²/200lb PAPER • 40 MINUTES

When water is very calm and the sun is strong, some reflections of boats almost seem to join up with the boat itself.

On this very bright morning the two canal boats moored further up stream were very quiet. Their reflections and those of the buildings and banks were sharp and almost brittle.

If I want to work from still water, I anticipate that I will have to do so before 8 o'clock in the morning or after 6 o'clock in the evening in order to have the best chances, even in good weather.

Canal boats, Wales

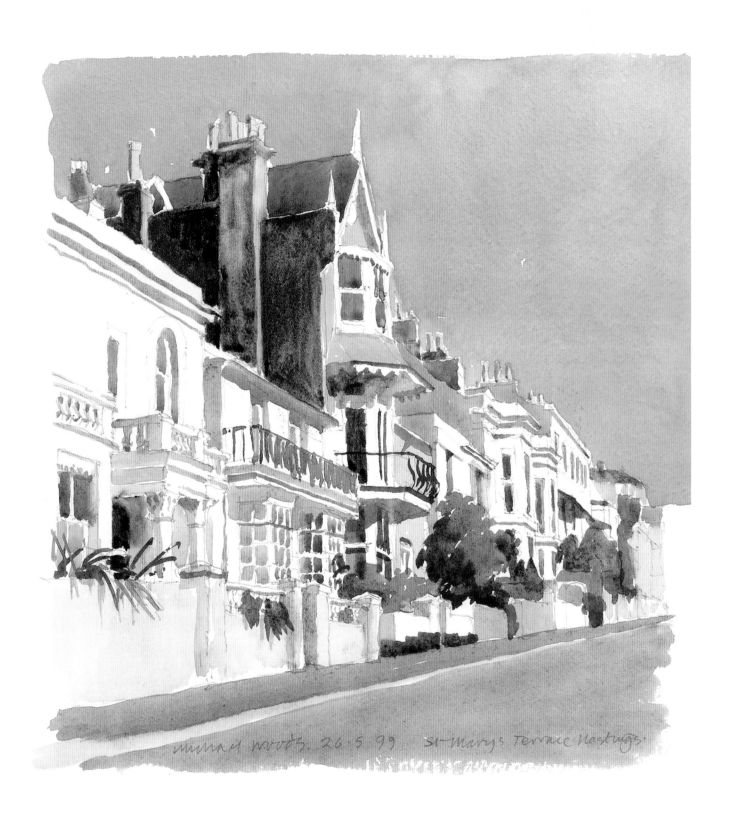

michael woods. 26·5·99 St Marys Terrace Hastings.

washes of colour. Most of this feeling of light comes from the shadows under the eaves, balconies and canopies.

HASTINGS, LIGHT AND SHADOW, 1998
• 18 x 10cm/7 x 4in • BLACK WATER-SOLUBLE INK ON FABRIANO 280g/m²/130lb PAPER • 15 MINUTES

I made this drawing because I suddenly saw the strong sunlight on the two end walls of this group of shops on Hastings front. The main facades were in shadow as were the people looking in the shop windows. There was also a fair amount of reflected light off the road. What is interesting is how much feeling of light there is off those two walls. They seem slightly brighter than the sky and yet both are untouched white paper. The areas of shadow set up the areas of light.

Opposite: St Mary's Terrace, Hastings, England.
Left: Hastings, light and shadow.
Below: Florence tower room.

Sketching in Sunlight

ST MARY'S TERRACE, HASTINGS, ENGLAND, 1999
• 23 x 20cm/9 x 8in • PENCIL, WATERCOLOUR ON BOCKINGFORD 425g/m²/200lb PAPER • 1½ HOURS

This handsome row of houses lies on a sweeping hill and faces roughly south-west. The day had a clear blue sky and the houses looked good in the strong light. I happened to be passing at the right time on the right day. I drew the houses faintly in pencil because I really had only one chance for each wash of colour and the placing needed to be correct. Although no house was complicated, the fact that they were all different made the inter-relationships quite tricky, and I wanted to preserve at all costs the strong light on their facades by using single

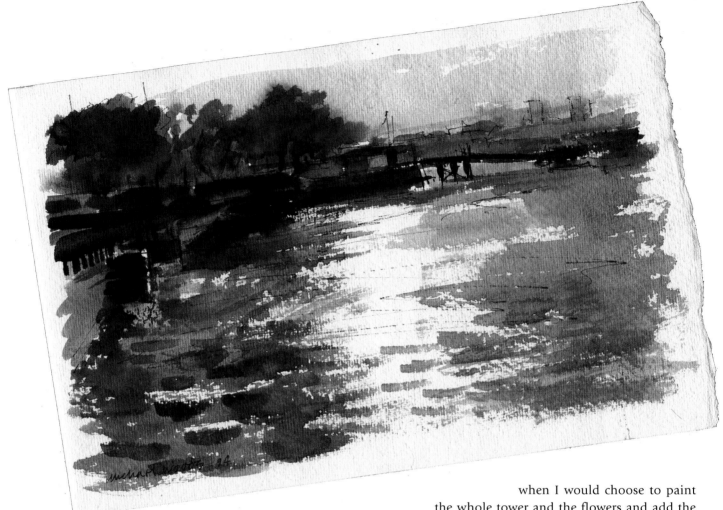

FLORENCE TOWER ROOM, ITALY, 1990

• 23 x 20cm/9 x 8in • PENCIL, WATERCOLOUR ON WHATMAN 300g/m²/140lb PAPER • 40 MINUTES

Greenwich, London

This was part of an old large rambling building on Bellosguardo in Florence. The complex was divided into several residences and although, while staying in one, I could see this tower that belonged to another, I never did find out who had built it or for what purpose.

Late one afternoon I saw that the sun was glowing off the walls and the little window box had a shadow that was just right. The frustration with this sort of subject comes when I would choose to paint the whole tower and the flowers and add the shadow of the flowers last, but even as I started the shadow was moving to the right, getting longer, and the whole wall was soon to fall into total shadow. So the wall, the flowers and their shadow had to be dealt with first, and all else, which was not so critical, built around it afterwards.

GREENWICH, LONDON, ENGLAND, 1994

• 18 x 25cm/7 x 10in • BROWN WATER-RESISTANT INK, WATERCOLOUR ON INDIAN HAND-MADE PAPER • 15 MINUTES

The sunlight on the Thames was almost blinding. It wasn't until I was trying to deal

with that brilliance and the sparkles that I appreciated how helpful the texture of the paper was, for by keeping the brush as dry as I could, while still delivering some paint, it only caught on the bumps of the surface. When dealing with extremely strong light, it will seem as bright as possible if everything else is a little darker in tone than you might first decide.

PRINCES AVENUE, CHARTERHOUSE, GODALMING, SURREY, 1994
• 16 x 25cm/6¹/₂ x 10in • BROWN WATER-RESISTANT INK, WATERCOLOUR ON HAND-MADE INDIAN PAPER • 30 MINUTES

I knew this little avenue well and it could look good at many times of the year. This early May day was very bright and the fresh leaves looked particularly picturesque. By standing in the sunlight the road became a dappled tunnel, with the two rows of trunks as the side walls, the branches above almost cutting out the sunlight and the shadows across the road surface making the fourth side. This sort of green tunnel is repeated very often in wooded country areas, only in many situations you cannot stand to paint in the middle of the road. Here I could, so I took the opportunity.

Princes Avenue, Charterhouse, Surrey

LESSINGTON BRAKE, CHARTERHOUSE, GODALMING, SURREY, 1989
• 20 x 30cm/8 x 12in • WATERCOLOUR ON WHATMAN 300g/m²/140lb PAPER • 30 MINUTES

For many years I used this group of buildings as a summer drawing subject for pupils; it was close and useful for conversations about colour and tone. It was late in the afternoon of that July day and I went the few yards to make a quick study in order to clarify the points about which I was talking. I have had the sketch in one of my portfolios ever since and it still evokes the time and the place, with the warm strong light, in a particularly special way.

The cottage on the left was built of bargate stone, so the left-hand wall is made of the same material as the wall below the white barge board. In and out of the sunlight they are quite different. The roof was plain tiles while the next roof was slate and, because it is reflecting some light from the sky, is a blue. The white window with 12 panes of glass has a shadow across part of it. The shadow is another blue. The road on the left is a buff pink – the shadow of the house on it is a purple blue. But the sketch is not so much about buildings as using them to say, 'Look, the sun is out on the afternoon of the 3 July 1989.' Sometimes that's all painting is about!

Lessington Brake, Charterhouse, Surrey

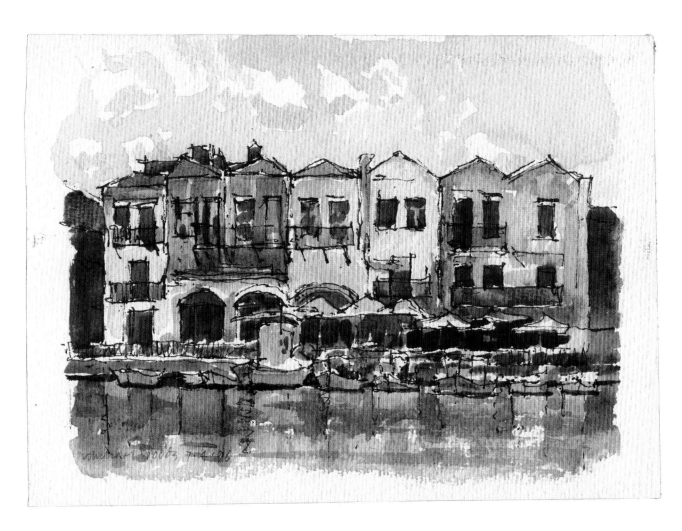

Food for Thought

HERAKLION, CRETE, 1996
- 13 x 16cm/5 x 6½in • BURNT UMBER, WATER-
RESISTANT INK, WATERCOLOUR ON HAND-MADE
INDIAN PAPER • 20 MINUTES

Three of us arrived at Heraklion harbour just
as lunch beckoned. We had enjoyed buying
various good things that were to be our
picnic. We walked around passing many boats
and headed towards the lighthouse. Finding a

pleasant raised level of stonework we stopped. I had been viewing potential subjects all the way – this is something I always do. The view back across the harbour was full of interest, and as I ate I decided that I would stay where I was and draw part of that view with boats and restaurants at the water's edge. The advantage of sitting, eating and looking is that it gives a good chance for consideration. Frequently in a hurry to get a subject down on paper, some qualities can become overlooked. There is much to be gained from the pre-drawing picnic.

LUNCH IN PARIS, 1998
• 13 X 18cm/5 X 7in • BLACK WATER-SOLUBLE INK ON FABRIANO 280g/m²/130lb PAPER • 20 MINUTES

During lunch I had studied these curious shapes and before leaving I decided to make a drawing that just might be developed. I realized that a lot of the shapes did not read easily – that was why I was doing the drawing anyway. The dark horizontal shape at the bottom was a room divider. Two illuminated lights stood on the top of this together with a curved rail joining a vertical post with a blob on top. Four people were sitting around a table eating and talking. Beyond them the wall of the restaurant had a wooden framework with large glass windows. On these were etched Art Nouveau shapes and borders, and one had a large oval that I suspect had lettering facing the street but was a mirror on the inside reflecting the darker parts of the room behind me.

As I drew I knew that I was really up against tonal problems because my black pen and spit wash were not subtle enough to get the full range of tones and colours involved. Yet by making a sketch, at least I had got a framework for thought.

BOAT QUAY, SINGAPORE, 2000
• 18 X 23cm/7 X 9in • BLACK BRUSH PEN, WHITE BALL PEN ON GREY 150g/m²/70lb PAPER • 10 MINUTES

Some of the best times of a painting day come in the evening when most brushes have been washed and a rewarding meal is anticipated. I was in Singapore working on a commissioned portrait, and at the end of a sitting my wife and I were enjoying the warm evening on Boat Quay waiting for our supper to arrive. Fatal! I suddenly noticed that the view along the water front was rather spectacular. Brightly lit small restaurants lined the water's edge and huge new buildings loomed up behind. I only had 5 or 10 minutes to juggle with a brush pen and a white ball pen. I just drew my reactions and halted as the first dish was served. Sometimes life presents just the right moment to stop.

Boat Quay, Singapore

Chapter 4

Technical Notes

Linocuts

One of the most pleasant ways of developing a sketch is to make a print of the subject from a linocut. Simple print making not only reveals its potential, but can serve as a self-tutor on the qualities of the original sketch. It tests how much was actually seen, understood and recorded. It may also test how much else can be remembered.

Print making also serves well at times when confined to the studio. I have shown several prints that I have developed from sketches. There are no absolute rules of procedure, but I do find certain methods work quite well.

Having selected the sketch to be developed, it is important to get the image to the right size. If starting, hand size is a good guide – in other words, 13 or 15cm/5 or 6 in. I then trace the main lines of the sketch and with black or white paint translate the image into the tonal design. Black paint will represent the parts that will

Stonehenge, Salisbury, England – black paint preparation

print. In a bold simple design this can work well, but if there is an area of small marks in a texture the little spaces left to be cut away can be quite difficult to deal with. If white paint is used to make the design, representing the areas to be cut away, your mind will be more focused on the cutting of the areas and adjustments can be made to the design to deal with any likely problems. When using white paint, lay the tracing over a dark surface so that some contrast is achieved. Applying the paint with a fine round brush, the lines made will closely represent the lines it is possible to cut with a lino-cutting tool.

When the design is satisfactory – maybe after making two or three versions – take a tracing of the new design and transfer this on to the rectangle of lino. Older lino was brown and quite hard; in fact when very cold it was almost impossible to cut – warming it helped a lot. Recently a grey coloured lino has become available that is softer, more like a solid cork,

and this cuts well. But because it is softer, care has to be taken with fine corners for the material can crumble. It is also a good idea to glue the rectangle of lino to a sheet of plywood or chipboard so that it is firmly flat and has a greater thickness, which gives a better clearance from the table when rolling it with ink.

If you want the image to be the same way round as the original sketch, then it has to be in reverse on the lino so that the printed image returns it to normal. I find it a great advantage to then re-paint the design on the lino. If the water paint is slightly rejected by the lino surface use a little domestic vinegar as the wetting medium. With the design finalized on the lino, then all concentration can be given to the cutting and this needs to be done with some freedom of movement. But, never turn your cutter towards your lino holding hand. Always cut away from yourself and turn the lino instead. This reveals the advantage of having the complete design shapes on the lino surface, for some of the image may be cut upside down.

Cut a batch of good quality cartridge paper so that it is at least 5cm/2in bigger on each side than the block.

Two artichokes
– white paint
preparation

When rollering the ink on to the lino block surface do not overload the quantity or the smallest lines will get filled with ink. I use a good-quality water-based printing ink, which has the great advantage that it is simple to wash off and dry when lines get clogged.

When the block is satisfactorily inked up, lay a piece of paper on top – don't put the block on top of the paper. I get a print by rubbing the paper firmly with my thumb. First prints are hardly ever fully inked but by the third, the print should be solid. Half the paper can be carefully peeled away to view the condition and then pressed back and problem areas given extra pressure. The other half can be similarly treated.

Allow newly made prints to dry overnight.

Scaling Up

Although there are a number of ways to enlarge or reduce the size of a sketch by specialized machines such as a photocopier, there can be limitations as well. It may take some time to get exactly the size wanted, and this is not always helped if someone else is in charge of the machine. If the final enlargement is to be several feet then many machines will not work to that scale. However, there is another very simple system that may be helpful. It uses no measurements and no complicated calculations have to be undertaken.

- To keep the original drawing clean, cover it with tracing paper or tri-acetate film (which is totally clear).
- Draw the rectangle you have chosen round your drawing or composition.
- Draw the first diagonal.
- Draw the second diagonal.

Right: Scaling up a grid sequence.
Opposite left: Enlarging using the diagonal.
Opposite right: 2 L-pieces.

- Draw the vertical and horizontal, making the quarters.
- Draw the diagonals within the quarters.
- Draw the verticals and horizontals in the quarters.
- Draw the remaining diagonals needed in the 16 rectangles.

If a fine grid is required another set of divisions can be constructed. This rectangle must then be duplicated at the larger size by the use of the very first diagonal. Any two rectangles having the same proportion will have their diagonals common to one another. So place the corner of the sketch rectangle with its diagonal in the corner of the new sheet, and with a long ruler or straight edge, project it until it meets the first boundary. Then, extremely faintly, draw exactly the same sequence of grid making on to the new surface. With the sketch grid over the sketch, all the objects, lines and shapes can be placed with considerable accuracy on the new size sheet. If the new work is to be on something like a canvas that already has its proportion fixed, draw the diagonal of the canvas on to a piece of paper. With this diagonal, decide on the best rectangle to use on the original sketch.

A right angle can be found on any good paper, such as computer or drawing paper, and the only important implement to have to hand is a long straight edge. An aluminium strip from DIY suppliers is excellent.

When making decisions about picture composition, two pieces of L-shaped paper or card are extremely useful. An old mount cut into two pieces can serve in this way.

Making a Wax Stick

I've not yet found a supplier of small uncoloured wax sticks. I decided that for some of the things I wanted to do a wax stick would produce a drawable line that would resist further watercolour washes. I also wanted it to be immediately usable, for although masking fluids do a good job in the studio, they involve rather slow and careful handling. It has to dry and cleaning brushes needs solvents, so for sketchbook work it is too involved for me.

I selected some aluminium angle section with sides about 2cm/3/$_4$in. I cut some pieces of cork to support it as a V-section trough. The two open ends were blanked off with two pieces of

*Trough for
casting wax
sticks*

shaped cork taped into place. I checked that the whole thing was secure and in a horizontal position.

Using the remains of a large white candle and a small gas blow-lamp, I melted some of the wax with care and let it drip into the mould. It started to set again quite quickly but while still warm I ran a fine palette knife down both sides freeing the triangular wax stick. The triangular section is ideal for making reasonably fine lines. Because the wax is quite soft it is easily pared to any tip useful in drawing and painting. Any off cuts and odd pieces can of course be re-melted.

Sketchbook Covers

Because I stretch my own canvases I tend to have off-cuts of canvas that make ideal sketchbook covers, but any slightly rough, matt-surfaced, thinnish material is good. Two pieces of firm card are needed. These should be about 6mm/$\frac{1}{4}$in bigger in dimension than your chosen paper. This will provide a 3mm/$\frac{1}{8}$in cover protection on each of the four sides.

Place the two pieces of card side by side leaving a spine gap, which controls how many sheets of paper can be held at any one time. This gap should be about 18 mm/$\frac{3}{4}$in. This dimension is quite critical because while, when the two sheets of card are open flat the gap seems generous, when it is closed as a book the two thicknesses of board will reduce the space left for the drawing paper. Then measure the canvas required, allowing approximately an extra 25mm/1in all round.

So with a paper size 25 x 36cm/10 x 14in and allowing for about 16 sheets of various papers, a comfortable gap of 12mm/$\frac{1}{2}$in is needed. If the card is 3mm/$\frac{1}{8}$in thick, a spine gap of 18mm/$\frac{3}{4}$in is required. The cards need to be 26 x 37cm/10$\frac{1}{4}$ x 14$\frac{1}{4}$in. The canvas needs to be,

say, 59 x 41cm/23^1/$_4$ x 16^1/$_4$in. Use an acrylic glue for sticking and stay about to smooth and press edges down as the glue dries off.

Make two bands of 9-cord elastic. Glue the two ends and overlap them and then put a small staple through the joint. They hold very well and lie flat. Always have some spares to hand. Some of mine have pinged away to unreachable places!

Sight Size

We all tend to draw with individual characteristics but sketching tends to work best when the size is comfortable for the circumstances – in other words, for drawing fairly small. My most useful size paper is 25 x 36cm/10 x 14in.

When observing a subject it is likely that the eye and brain will make it a certain size and this is known as sight size. It is extremely useful because it produces a constant situation by which things can be judged and even measured. This facility is not always needed but sometimes it is helpful to divide, for example, a landscape into three, or compare the ratio of parts of a building, or simply to decide the placing of elements on the paper. If you stretch your arm out, holding a 30cm/12in ruler horizontally, the length is just about what can be seen without moving your eyes. That 30cm/12in fits into my 36cm/14in paper.

Now I don't draw with a ruler, but I do hold up my pencil or pen. The distance from the eye to my stretched out hand will be pretty constant. Using the tip of the thumb as a movable measure and the pencil end as the start, the length of part of a subject can be measured. Keeping the thumb at the same point the hand can be moved to another part of the subject and the two parts compared. If this dimension is

taken to the drawing paper, then the drawing will be the same size as the sight size view. I generally only use actual measuring when a subject is very complicated or when I want to get proportions or ratios correct. Sometimes it is useful before starting to check if a subject will fit on to the paper. Even if a drawing is to be made larger or smaller, the pencil measure can be used to find, say, a halfway point that can be surprisingly helpful.

Lightfastness

Many materials that the artist may use should be considered for their degree of lightfastness. Some may provide this information, but if there is any doubt it is not difficult to do a test.

On a piece of firm card – an off cut of mounting card is ideal – make a line one-third from the left-hand edge. In this third write the date and the name of the ink or paint to be tested. On the two-third area, apply lines and a broad stripe of the ink or paint. Put some lines down with a single mark, others with several applications. Then fold the card down the one-third line so that half the material under test is covered while the remaining half is exposed. Ensuring that the fold lies closed, place the card in a south facing window and leave it for two or three weeks.

When you examine it by unfolding the card, you may be surprised by how much the exposed material has faded. Of course drawings that remain in a closed book will be fine, but those that are removed for development purposes or those on loose-leaf sheets and possibly framed and displayed may be vulnerable to strong light. At least it's worth knowing what quality of materials you are using.

Glossary

Book proportions

Landscape
A book where the spine is shorter than the width of the page, i.e. like the proportion of many landscapes.

Portrait
A book where the spine is longer than the width of the page, i.e. like the proportion of many portraits.

Capital

The head or top feature of a column.

Field Brush

A small brush that has a short handle enabling it to be carried in a pocket for sketchbook work outside. Some are available with a handle, which can cover the hairs for protection.

Ink

Pigmented inks may be more permanent to light.

Water-resistant/waterproof
Ink that when dry can no longer be dissolved or moved by water. The drying time, after which they are totally resistant, can vary so testing is necessary.

Water-soluble
Ink that, when dry, can be re-wetted with water and moved.

Lino/Linoleum

Originally a tough floor covering. For print making earlier forms were equally tough and often needed warming before cutting was possible. A new grey form is softer and simpler to cut but can crumble if care is not taken.

Palette Knife

A small, flexible, bladed spatula made in a variety of shapes for mixing pigment and moving paint.

Paper

Acid free
Many papers are acid free to ensure that they do not discolour themselves or harm the materials laid on them.

Cartridge
A good quality but economic paper frequently found in sketchbooks. Good for drawing.

Deckle edge
A rough edge on some hand-made papers.

Mill
The name of a first-class paper mill will be associated with the names of the papers it produces. It may be a useful guide when selecting paper because the range offered will be of a similar quality throughout.

Sugar
A rather coarse, less expensive paper made in a range of colours. Susceptible to fading and colour change.

Surfaces

Extremely smooth, almost shiny surfaces are used by the printing industry.

Matt, soft surface, water-absorbent papers are used by artist print makers. Good for washes but dent easily.

Watercolour paper – smooth is defined as HP (Hot Pressed); slightly rough is defined as Not (Not Hot Pressed), also known as CP (Cold Pressed); rough paper is simply defined as Rough and has the most pronounced surface.

Watermark

A paper maker's symbol or name found in the corner of sheets and seen against a light source by a slight thinning of the paper.

Weight

Imperial system the measure was given as pounds per ream (480 sheets) for a specified size; the greater the pounds the thicker the paper. A good paper would be 140lb.

Metric system the measure is in grams per square metre. The pack size is now likely to be 500 sheets rather than 480. So a paper of 140lb is described as 300g/m². (Comparisons between imperial and metric weights can sometimes vary.)

Pen

Brush

A type of brush that is fed with ink from a cartridge in its handle.

Fountain

A classic pen that has a semi-flexible nib and a refillable container for ink or a replaceable cartridge. At best it can produce lines of various widths with great subtlety.

Roller/ball

Proprietary brands of pens for making lines use a variety of descriptive terms. The general system is a ball at the end of a tube, which supplies the ink.

Technical

A pen that has a refillable container or cartridge for the ink, which is delivered down a fine tube with an even finer rod inside it. It is ideal for technical drawings where a line of regular width is required. Different pens are made to produce different line thicknesses.

Pilaster

A shallow pier or column projecting only slightly from a wall.

Tri-acetate film

A rather expensive transparent sheet, which will lie perfectly flat on a drawing and on which further tracing, drawing or watercolour work can be developed.

Voussoir

A brick or wedge shaped stone forming one of the elements of an arch.

Watercolour

Tubes are too complicated when sketching. Pans – little firm blocks of pigment – are ideal in a purpose-made box. Whole pans are about 3 x 2cm/1¹/₄ x ³/₄in. Half pans are 15 x 18mm/ ⁵/₈ x ³/₄in, which provide ideal quantities while allowing a bigger range of colours.

Suppliers

USA

Cheap Joe's
374 Industrial Park Drive
Boone
NC 28607
Tel: 1 800 227 2788

Daniel Smith
PO Box 84268
Seattle
WA 98124-5568
Tel: 1 800 426 6740

The Italian Art Store
84 Maple Avenue
Morristown
NJ 07960
Tel: 1 800 643 6440

Jerry's Artarama
PO Box 586381
Raleigh
NC 27658-8638
Tel: 1 800 827 8478

New York Central Art Supply
62 Third Avenue
New York
NY 10003
Tel: 1 800 950 6111/212 477
0400 (in New York State)

Pearl Paint
308 Canal Street
New York
NY 10013
Tel: 1 800 221 6845/212 431
7932 (in New York State)

Sanford
Bellwood
IL 60104
Web site:
www.sanfordcorp.com

Utrecht Manufacturing
6 Corporate Drive
Cranbury
NJ 08512
Tel: 1 800 223 91321

UK

Alexander's Art Shop
58 South Clerk Street
Edinburgh EH8 5IPS
Tel: 01316 675257
Web site: www.
alexandersartshop.co.uk

Atlantis Art European Ltd
146 Brick Lane
London E1 6RU
Tel: 020 7377 8855

Daler Rowney Ltd
PO Box 10
Bracknell
Berkshire RG12 8ST
Tel: 01344 424621
Fax: 01344 486511
Web site: www.daler-
rowney.com

Daler Rowney Ltd
12 Percy Street
London W1A 2BP
Tel: 020 7636 8241

Falkiner Fine Papers Ltd
76 Southampton Row
London WC1B 4AR
Tel: 020 7831 1151
Fax: 020 7430 1248

Green & Stone
259 King's Road
London SW3 5EL
Tel 020 7352 0837
Fax: 020 7351 1098
Email: mail
@greenandstone.com
Web site: www.
greenandstone.com

L Cornelissen and Son
105 Great Russell Street
London WC1B 3RY
Tel: 020 7636 1045
Fax: 020 7636 3655
Email: info
@cornelissen.com
Web site: www.
cornelissen.com

Norwich Art Suppliers
16 St Benedicts Street
Norwich NR2 4AG
Tel: 01603 620229
Email: daniel
@norwichartsupplies.
freeserve.co.uk

Paintworks Ltd
99-101 Kingsland Road
London E2 8AG
Tel: 020 7729 7451
Fax: 020 7739 0439
Email: shop@paintworks.biz

Pentel (Stationery) Ltd
Hunts Rise
South Marston Park
Swindon
Wiltshire SN3 4TW
Tel: 01793 823333
Fax: 01793 823366
Email: salesoffice
@pentel.co.uk
Web site: www.pentel.co.uk

Robersons and Co Ltd
1a Hercules Street
London N7 0AT
Tel: 020 7272 0567
Fax: 020 7263 0212
Email: info@robco.co.uk

Rotring UK Ltd
430 Strathcona Road
Wembley
Middlesex HA9 8QP
Tel: 020 8908 2577
Fax: 020 8908 4580
24-hour message service: 020
8908 4476

Royal Talens
Distributed by Royal Sovereign
Ltd
7 St George's Industrial Estate
White Hart Lane
London N22 5QL
Tel: 020 8888 6888
Fax: 020 8888 7029

Email: info@royal-
sovereign.com

Sanford UK
Oldmeadow Road
Kings Lynn
Norfolk PE30 4JR
Tel: 01553 761221
Fax: 01553 766534
Email: @sanford-uk.com
Web site: www.sanford.co.uk

Winsor & Newton/
ColArt Fine Art & Graphics Ltd
Whitefriars Avenue
Harrow
Middlesex HA3 5RH
Tel: 020 8424 3200
Web site: www.
winsornewton.com

Australia

Winsor & Newton
Jasco Pty
118-122 Bowden Street
Meadowbank
NSW 2114
Tel: 2 9807 1555

Daler Rowney Ltd
Rossdale
137 Noone Street
Clifton Hill
Melbourne
Vic 3068
Tel: 3 9482 3988

Right: Mariinsky Theatre, St Petersburg

Index